The Impressionists

Auguste Renoir

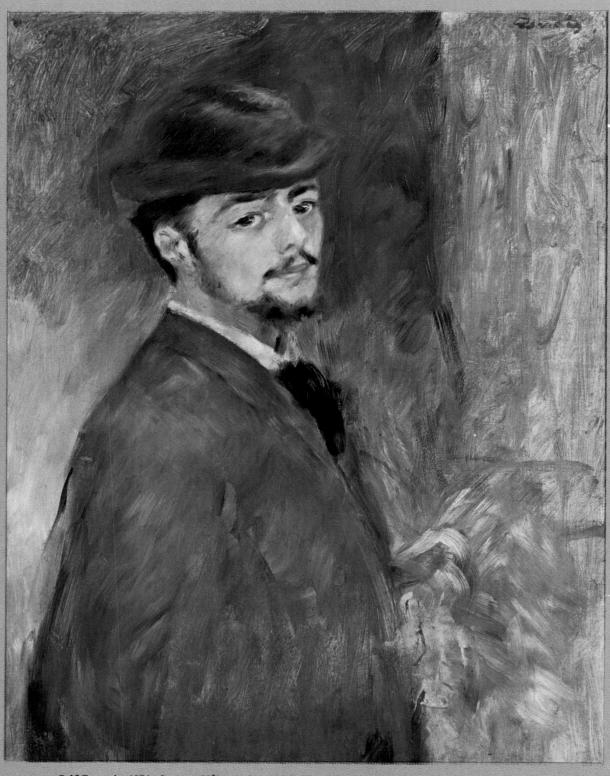

Self-Portrait, 1876. Canvas, $28^{3/4} \times 22$ in. Cambridge (Mass.), Courtesy of The Fogg Art Museum, Harvard University, Maurice Wertheim Bequest.

Auguste Renoir

François Daulte

Contents

Why I love Renoir by Maurice Genevoix	5
Memories of my brother by Edmond Renoir	7
Life and Works	
Initiation into beauty	10
Through Impressionism	24
The conquest of Classicism	36
The patriarch of Les Collettes	60
Documentation	
Renoir year by year	74
Expertise	84
Renoir and the Bérard family	86
Rooks about Renair	94

Series edited by Daniel Wildenstein Produced with the collaboration of the Wildenstein Foundation, Paris

Reproduction of the works of Renoir © SPADEM, Paris

Photo credits: Durand-Ruel Archives, Paris; François Daulte Archives, Lausanne; Wildenstein Archives, New York; Gruppo Editoriale Fabbri, Milan; Robert Schmit, Paris; Roger-Viollet, Paris; Paul Rosenberg & Co., New York; Josse, Paris; Giraudon, Paris; Clichés des Musées Nationaux, Paris; Bulloz, Paris; Jean Clergue, Cagnessur-Mer; Knoedler, New York; Sam Salz, New York; Routhier, Paris; Steinkopf, Berlin

Copyright © 1972 Gruppo Editoriale Fabbri, Milan English language text Copyright © 1973 by Gruppo Editoriale Fabbri, Milan

Published in USA 1988 by Exeter Books Distributed by Bookthrift Exeter is a trademark of Bookthrift Marketing, Inc. Bookthrift is a registered trademark of Bookthrift Marketing, Inc. New York, New York

ALL RIGHTS RESERVED

ISBN 0-671- 09412-2

Printed in Italy by Gruppo Editoriale Fabbri, Milan

Why I love Renoir

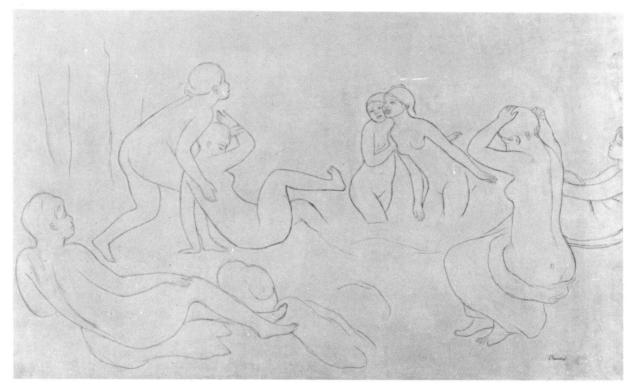

Study for "Bathers in the Forest", c. 1897. Pencil drawing, on tracing paper, $24^{3/4} \times 38^{5/8}$ in. Paris, Private collection. (Photo Robert Schmit)

All my life, I do believe, I have suffered from not being a painter. Such regrets give rise to fervent admirations. So it is that, from year to year, my memory has been peopled with masterpieces, the never-forgotten gallery of pictures I might have stolen. One of the very first was surely a canvas by Auguste Renoir, *Portrait of Madame Charpentier*. A justly famous canvas, yet I knew nothing of that—nor would this have mattered. It was on display in the little Luxembourg Museum in Paris, which regrettably has disappeared. It was positively radiant.

... The glow of that flesh, an inner light unquenchably welling up and radiating, what words could ever have expressed it? What investigations or technical analyses, be they the subtlest or most probing, would not in all fairness have given up on the threshold of the inexplicable, in the face of this rare and mysterious gift, this pictorial miracle?

Even after what I have just written, one must still resort to words. Ever since that faraway encounter, Renoir seemed for me to stand among the great masters, those I call the miracle-makers; and in that picture, besides an impressive facility, I found a joy and youthfulness that brought me—in my own youth, in my own time—with some vital impulse into its creator's own marvelous actuality. Impressed by Baudelaire and that "Novelty" he called for, I found in it intoxicating proof that the world was inexhaustibly new and that such a privileged intermediary was enough to lead us toward the unsuspected, toward the poetry of things and to the illumination of art.

All this lyricism over a portrait! How could it be otherwise? What return to vital sources is not accompanied by this sort of excitement? Later, without ever having had the privilege of meeting Renoir, I came to know some of his intimates. From those

who had witnessed it, I learned about his long struggle, his hard life, and his martyred later years. In the home of one of his comrades at the École des Beaux-Arts, who used to put him up in the lean years, I saw the canvases he had left there in gratitude. These eventually "went up" so much in value they caused the heirs of this generous host to fall out among themselves. From this ironic and fit change of circumstances, my affection for Renoir would have

grown still more, had that been possible. But, instantaneously, it had already reached that point of perfect love which could never be surpassed. For, even before I came to know that dazzling litany I now recite to myself (*The Loge, Le Moulin de la Galette, The Bathers, The Daughters of Catulle Mendès*, the "Nudes" of Gabrielle, and I could go on endlessly), that one encounter at the Luxembourg had sufficed.

How, after being a pupil of Gleyre, has Auguste Renoir become what he is? It was like this. At that time, much more than now, art students went trooping off to the Forest of Fontainebleau. They did not have studios of their own there, as you see today that was an unknown luxury! The inns of Chailly, and of Barbizon, and of Marlotte housed them all, big and little, and they would go off to work outdoors with a knapsack on their back. It was there that my brother met Courbet, the idol of the young painters, and Diaz, who was then admired even more. It was Diaz who gave him the best lesson he probably received in his whole life, when he told him that "no self-respecting painter should ever touch a brush unless he has his model in front of him."

This axiom stuck in the mind of the youthful beginner. He said to himself that flesh-and-blood models cost too much money and that he could get some on much better terms, for the forest was all around him, ready to be studied at leisure. He stayed there through the summer, through the winter, and eventually for years. By living in the open air he became the painter of the open air. The four bare walls of

the studio did not weigh on him; their uniformly gray or brown tone did not dull his eye. And so his surroundings had an enormous influence on him; having no memory of the drudgery to which artists all too often resign themselves, he allowed himself to be carried away by his subject, above all by the surroundings in which he found himself.

This is the special characteristic of his work. It is present everywhere and always, from his Lise, painted amid the forest, to his Portrait of Madame Charpentier and Her Daughters, painted in her home, without any of the furnishings being moved from where they stand every day, with no attempt to give prominence to any one part of the picture. Does he want to paint the Moulin de la Galette? He goes and installs himself there for six months and gets to know that little world with ways of its own, which no models seeking to copy those poses could ever capture; mixing in the frivolous whirl of that popular dance hall, he conveys its furious movement with a stunning verve. Does he want to do a portrait? He asks his model to keep to her usual behavior, to sit as she usually sits, to dress as she usually dresses, so that nothing smacks of constraint or artificial prepara-

Edmond Renoir Fishing. Pen drawing, $7^7/8 \times 12^{1/4}$ in. Viroflay, Private collection.

tion. Thus his work has, in addition to artistic value, all the charm *sui generis* of a faithful picture of modern life. What he has painted, we see before us every day; he has recorded our own lives in "pages" that will surely remain among the most vivid and harmonious of the period. ...

Looking at my brother's work as a whole, one sees that he does not have any set style. Probably in no two pictures does he proceed in quite the same way, and yet his work is a cohesive whole; it was perceived as such from the very start and pursued with the one idea of achieving, not perfection of rendering, but the most thorough comprehension of the harmonies of nature.

I promised you a portrait of him in twenty lines. You

have seen him a score of times rushing across the boulevard, pensive, dreamy, gloomy, withdrawn. Forgetful and untidy, he will come back ten times for the same thing without remembering to do it. Always hurrying in the street, always immobile when indoors, he can remain for hours without moving, or without talking. Where are his thoughts? On the picture he is doing or the one he intends to do; he speaks of painting, though, as little as possible. But if you want to see his face light up, if you want to hear him—wonder of wonders!—hum a lively tune, don't seek him out at table or in places where people go to have fun, but try to catch him while he's working.

Letter to Émile Bergerat, in La Vie Moderne, Paris, June 19, 1879.

Life and works

Initiation into beauty

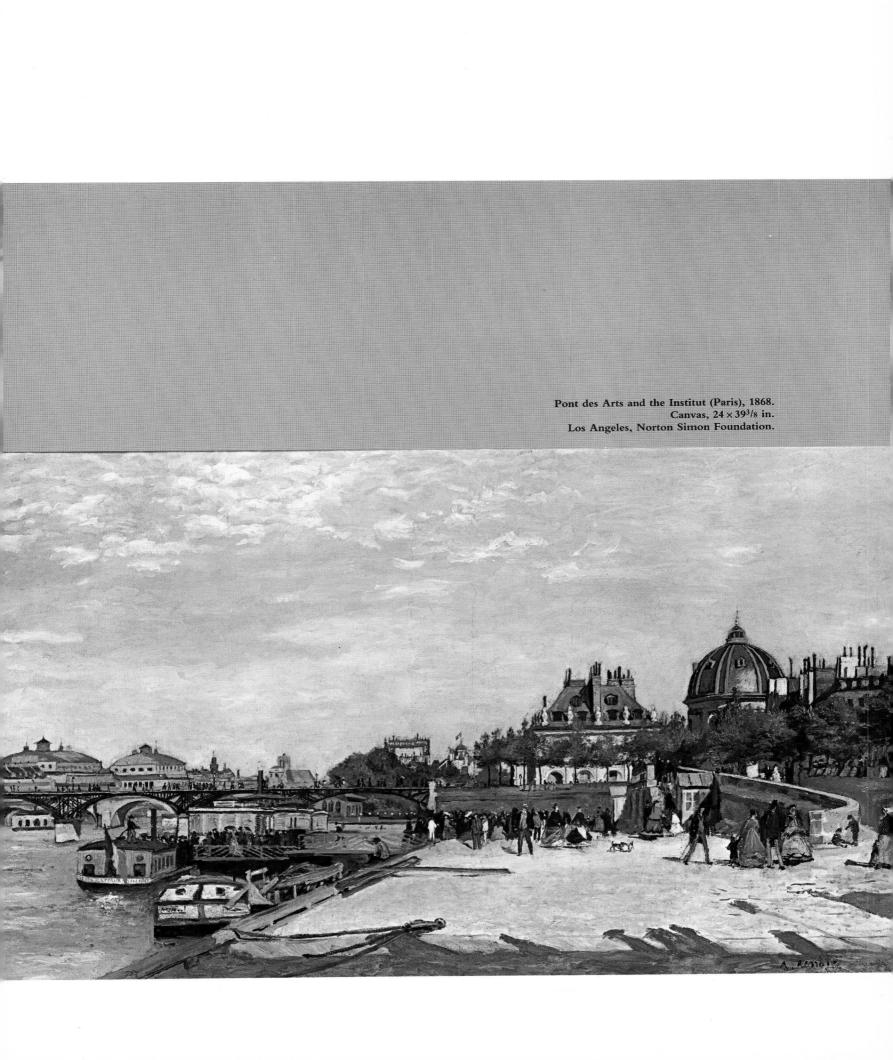

"Man lives and dies in what he sees, but he sees only what he dreams." These wise words of Paul Valéry relate to no one better than to Renoir. He was an artist who, all throughout his long career, retained no more of reality than what pleased him and who, in his paintings and pastels, as in his drawings, prints and sculptures, chose to represent those things which will always be a delight to men: children, full-blown women, fruit and flowers and pleasing landscapes, all of them bathed in resplendent light. Pierre-Auguste Renoir was born on February 25, 1841, in Limoges, in southcentral France, at No. 4 Boulevard Sainte-Catherine (today 35 Boulevard Gambetta). His parents were modest, lower-middle-class artisans of that city. His father Léonard Renoir was a tailor; his mother, born Marguerite Merlet, was a seamstress who came from Saintes in western France. Pierre was their sixth child, and three years after his birth Léonard Renoir left Limoges with his family and moved to Paris. There he found modest lodgings at 16 Rue de la Bibliothèque, near the Temple de l'Oratoire in the neighborhood of the Louvre. But working conditions were scarcely better in Paris than in Limoges, and with so large a family the tailor had a hard time making ends meet. At the age of seven, the future Impressionist was sent to a school run by the Christian Brothers, in the outbuildings of a secularized monastery near the Tuileries, where he was taught reading, writing, and arithmetic, and was also given the rudiments of musical education. But his parents, having noted his interest in drawing, withdrew him from the school in 1854 and apprenticed him to a firm of porcelain painters, Lévy

At the School of Design and Decorative Arts in Rue des Petits-Carreaux, then later at the École des Beaux-Arts, Renoir copied the Classical bas-reliefs and drew the allegorical nudes and mythological scenes prescribed by his teachers. A diligent and conscientious pupil, he did his best to grasp the secrets of tradition.

- 1 Hector and Paris, March 12, 1860. Pencil drawing, $8^5/8 \times 11^3/4$ in. Viroflay, Private collection.
- 2 Homer, January 11, 1860. Pencil drawing, $9^{1/2} \times 12^{1/4}$ in. Viroflay, Private collection.

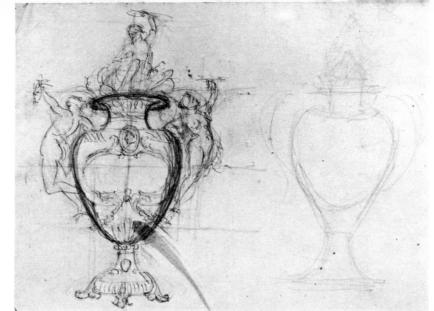

3, 4, 5 Studies for a Painted Vase, c. 1858. Pencil drawings, $9^{1/2} \times 12^{1/4}$ in. Viroflay, Private collection.

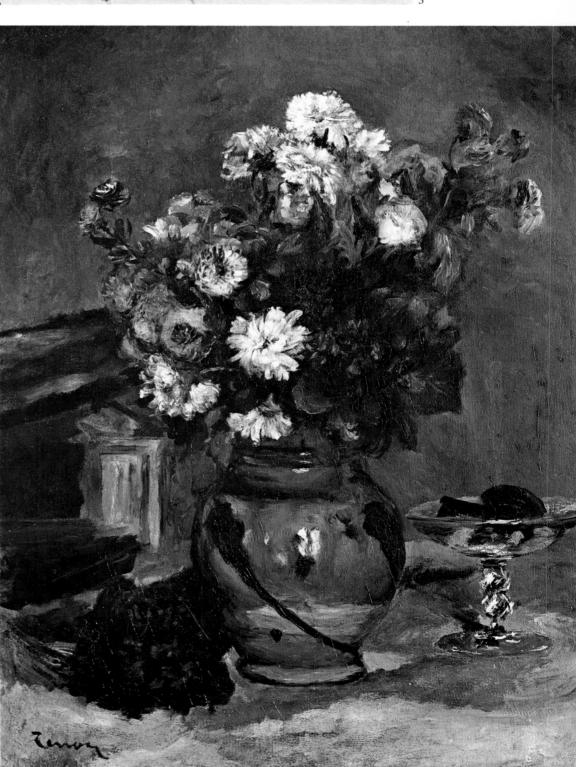

6 Flowers in a Jar and Champagne Glass, c. 1866. Canvas, 161/8×13 in. Private collection.

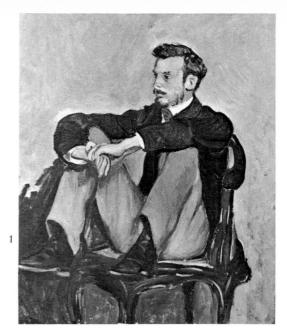

Frédéric Bazille: Portrait of Auguste Renoir, 1867. Canvas, $24^{3}/8 \times 20^{1}/8$ in. Paris, Musée du Louvre.

- Portrait of Renoir's Father, 1869. Canvas, 24 × 19 in. St. Louis (Mo.), The City Art Museum.
- 3 Portrait of Renoir's Mother, 1860. Canvas, $17^3/4 \times 15$ in. Zurich, Private collection.

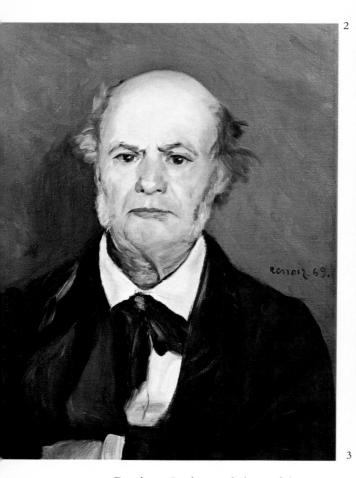

Callouette. There he struck up a friend-

Brothers. In the workshop of these excellent craftsmen young Pierre-Auguste began by painting designs on porcelain plates. He soon became skillful at this, and his employers entrusted him with more difficult assignments, such as inscribing a portrait of Marie-Antoinette on the side of a teapot or representing Venus in a swirl of clouds on the side of a vase. Almost every evening he attended classes at the School of Design and Decorative Arts in Rue des Petits-Carreaux, directed by the sculptor

ship with a fellow student, Émile Laporte. In his spare time Renoir liked to explore the streets in the older quarters of Paris. Near Les Halles he discovered and marveled at the Fontaine des Innocents and its bas-reliefs by the French Renaissance sculptor Jean Goujon; thirty years later, when he painted his Large Bathers, he had this work and that of Girardon in mind.

In the spring of 1858 the workshop of Lévy Brothers was forced to close

down. Hand-painted wares could no longer compete with the new industrialized methods then coming into use. In the porcelain business the future now lay with the machine rather than with handicrafts, and Renoir found himself out of work. But he had to earn a living and soon found another job with M. Gilbert, a commercial painter. For his new employer he painted devotional pictures, of the Virgin and Child or of St. Vincent de Paul, on canvas strips that could be rolled up; these were

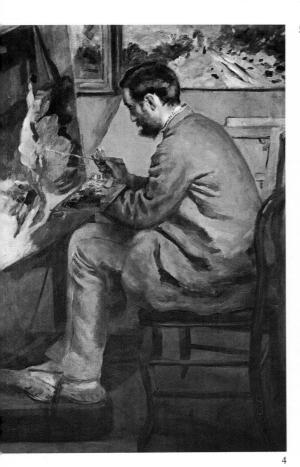

- 4 Portrait of Bazille, 1867. Canvas, 41³/₄ × 29¹/₈ in.
 Paris, Musée du Louvre.
- 5 The Inn of Mère Anthony, 1866. Canvas, 76³/₄ × 51¹/₄ in. Stockholm, Nationalmuseum.

While staying at Marlotte in the summer of 1866, Renoir painted his first large figure composition, The Inn of Mère Anthony, in which he already showed remarkable proficiency. On the right, wearing a straw hat and with the newspaper L'Evénement spread before him, is Alfred Sisley. Opposite, with his arms crossed, is the painter Jules Le Coeur. The old woman with a kerchief on her head and her back turned is Mère Anthony. Beside her daughter Nana who is clearing the table stands Claude Monet.

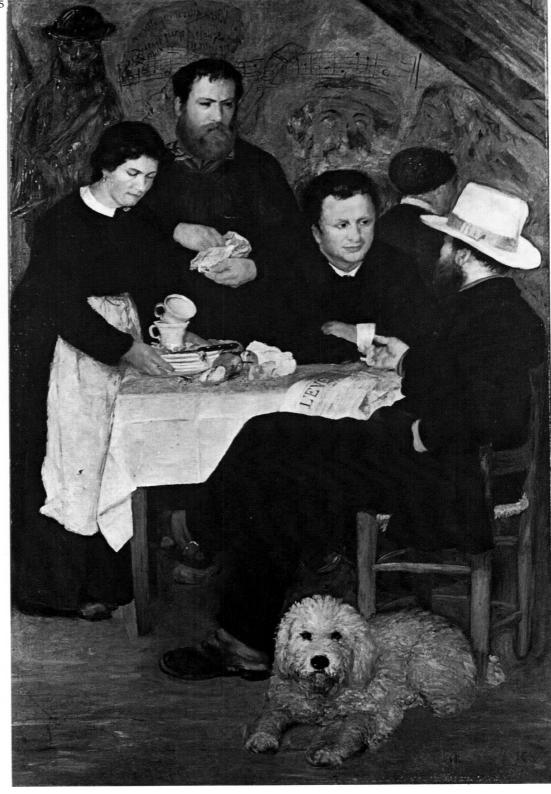

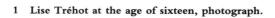

- 2 Diana, 1867. Canvas, 77 × 51¹/4 in. Washington, D.C., National Gallery of Art, The Chester Dale Collection.
- 3 Summer, or The Gypsy Girl, 1868. Canvas, 33¹/₂×24¹/₂ in. Berlin, Nationalgalerie. (Photo Steinkopf)
- 4 Lise, or Woman with a Sunshade, 1867. Canvas, 72¹/₂ × 45¹/₄ in. Essen, Folkwang Museum.

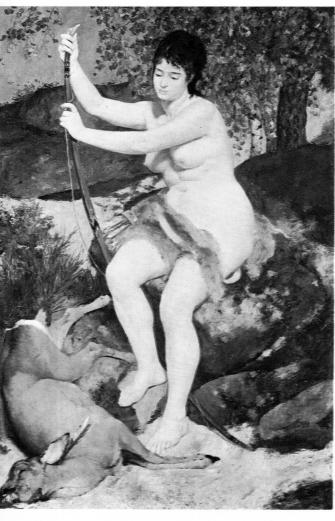

sold to missionaries, who took them to distant lands to hang in their makeshift churches. Being a fast worker, Renoir could paint as many as three such blinds a day, for which he was paid thirty francs apiece. At this rate he was able to save some money and soon broke away from this drudgery in order to realize his dream of devoting himself to painting in earnest. On the advice of his friend Laporte, Renoir decided to apply for admission to the École des Beaux-Arts. He passed the entrance examination-ranking 68th out of 80-and entered the school for the summer session. On April 1, 1862, he enrolled in

the studios of Émile Signol and Charles Gleyre, the latter a Swiss painter made famous by his large picture entitled *Evening* (or *Lost Illusions*).

During his brief stay in the old school of fine arts on the Quai Voltaire, Renoir was hardly noticed by his teachers and won no prizes. It would be a mistake, however, to imagine the young man was merely amusing himself in Gleyre's studio. Now as always, he painted for pleasure, but nevertheless was a conscientious student, profiting as much as possible from these lessons he paid for with money earned by his own efforts. Above all, in Gleyre's studio he had the

good fortune to meet and form close friendships with three artists of his own age: Claude Monet of Le Havre, Frédéric Bazille of Montpellier, and Alfred Sisley, an Englishman born and raised in Paris. Though quite different in background and temperament, these four young men soon became inseparable friends. All four were to play a significant part in that renaissance of French painting-now known as Impressionism-which was to renew man's contact with nature and light. A few months were enough for Renoir to realize that Gleyre's views on art were far removed from his own and from his

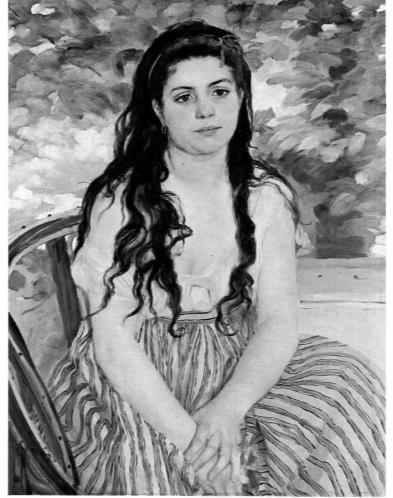

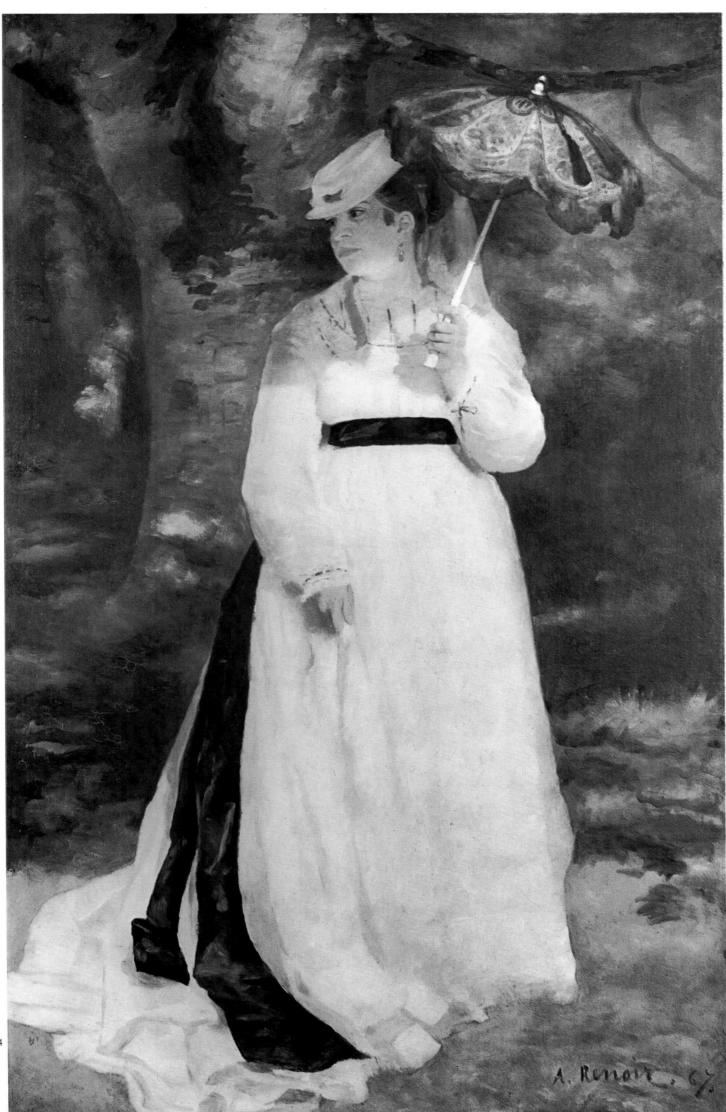

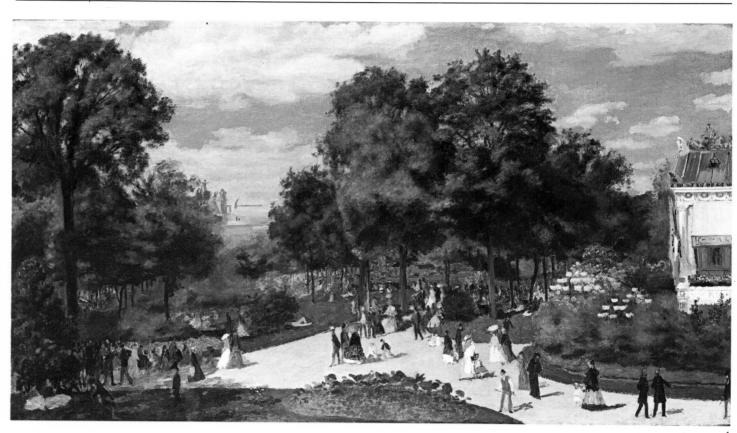

1 The Champs-Elysées during the Paris World's Fair of 1867. Canvas, 30 × 511/4 in. Zurich, Private collection.

friends' way of seeing. So he did not stay long at the École des Beaux-Arts. In the spring of 1863 he left Gleyre's studio, and his friends, the future Impressionists, went with him; together they migrated to the Forest of Fontainebleau, where they set to work painting in the open air or, as Cézanne was later to put it, "sur le motif." One day, while working in a clearing, Renoir made the acquaintance of the painter Virgile-Narcisse Diaz, who encouraged him to use brighter colors. Another time he was fortunate enough to meet Gustave Courbet, whom both he and Bazille greatly admired. The master of Ornans seems to have encouraged the young painter and given him advice. Certainly most of the pictures done by Renoir in this early period show the influence of that celebrated painter of The

Artist's Studio and The Burial at Ornans. Until the Franco-Prussian War of 1870, Renoir spent holidays regularly in the Forest of Fontainebleau, taking board and lodging either with Père Paillard at the Auberge du Cheval Blanc in Chailly-en-Bière or with Mère Anthony at Marlotte. Several times, too, he enjoyed the generous hospitality of his friend Jules Le Cœur, who owned a pleasant, tree-shaded house at Marlotte, where he lived with his mistress Clémence Tréhot, daughter of the postmaster of Ecquevilly, in Seine-et-Oise. In the home of Jules Le Cœur, Renoir not only had the privilege of living with a well-to-do family with a taste for art and literature, but also discovered a new model in the person of Clémence's younger sister, the charming Lise Tréhot. At his first meeting with the

young woman, whose rustic grace won his heart at once, Renoir begged her to come and pose for him. Over the next few years he painted some twenty portraits of Lise, standing in a park, seated on the grass, or sitting at her needlework indoors. He also represented her as *Diana* (1867), as the *Woman with a Sunshade* (1867), as a gypsy girl against a background of greenery and symbolizing *Summer* (1868), and final-

La Grenouillère was a popular restaurant and bathing establishment on a small branch of the Seine between Chatou and Bougival; it was frequented by a crowd of artists, students, boatsmen, and pretty girls who came on Sundays and holidays to dance and swim. Maupassant used it as the setting for several stories. "It was a neverending party, and what a jumble of social sets!" Renoir later told his dealer Ambroise Vollard. "People still knew how to laugh then! Machinery was not everything in life. We had time to live, and we didn't fail to do so."

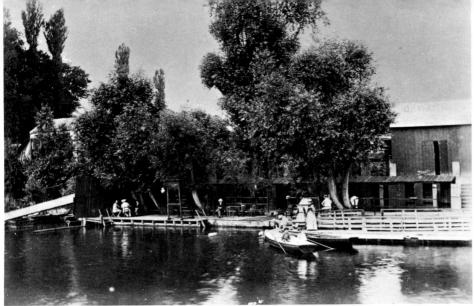

2 La Grenouillère in a photograph of about 1867. Paris, Sirot Collection.

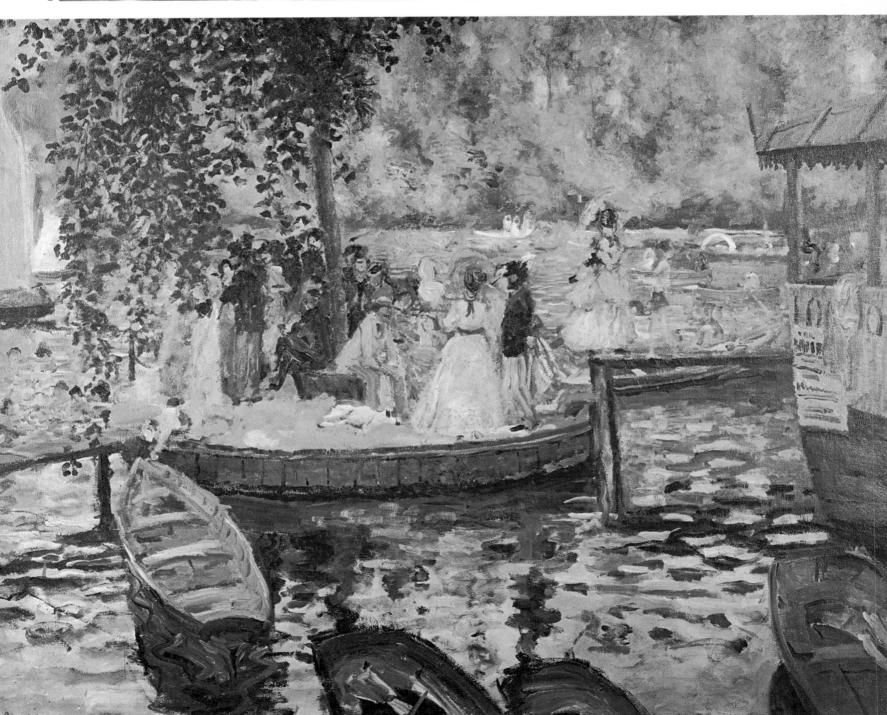

3 La Grenouillère, c. 1869. Canvas, 26×32 in. Stockholm, Nationalmuseum.

3

ly in the Odalisque, or Woman of Algiers (1870), a large canvas worthy of Delacroix.

In several portraits of Lise, particularly those he sent to the Salons, Renoir still used a traditional technique, with the fairly dark color scheme and smoothly blended paints. These are applied in broad bands, with scumblings that allow the priming coats to show through, and he laid on his colors in flat tints: warm browns, vivid greens, soft blues. If in Diana, for example, he painted with a heavy impasto, the pigments sometimes applied with the palette knife, and built up thick layers of colors reminiscent of Courbet, elsewhere (Woman with a Sunshade, Summer, and The Walk) he used more modern means that heralded the technique of Le Moulin de la Galette. As early as 1867, Renoir showed himself a firm advocate of bright color. He gave up his early primer coats of bitumen and began sketching his subject directly on the unprimed canvas. He took to using ocher and vermilion and replaced the earth colors of his earliest portraits with blues that add the poetry of light to the vitality of his forms. He tended toward a synthesis of the aims of pre-Impressionism and his own Classical tempera-

During the summer Renoir usually lived either with his parents, who had retired to Ville-d'Avray, near Versailles, or with Jules Le Cœur at Marlotte. In wintertime he often stayed with his more affluent friends. From 1867 to 1870 he began sharing Sisley's Paris studio at the Porte Maillot; then those of Frédéric Bazille, first in Rue Visconti, and afterward Rue de la Condamine in the Batignolles district. In the latter studio Renoir executed a charming and unusual portrait of his painter friend and host. Wearing red slippers, Bazille is seen sitting before his easel, with his elbows on his knees in a favorite working pose. His head bent forward slight-

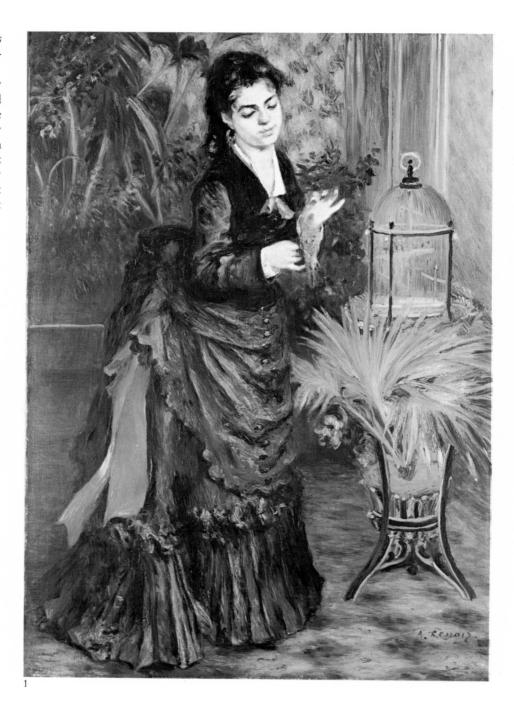

From 1865 to 1872 Renoir's mistress and favorite model was a young woman named Lise Tréhot, younger daughter of the postmaster at Ecquevilly (Seine-et-Oise). In February 1870 Renoir painted Lise as the Woman of Algiers, wearing an extravagant Oriental costume that would have delighted Delacroix. In 1871 he por-

trayed her, perhaps the last time, holding a parakeet in front of its open cage. Wearing a black taffeta dress with flounces, set off by a red sash, Lise stands out against a background of green plants. Avoiding the stiff poses of ordinary portraits, Renoir succeeded in conveying the atmosphere of a Second Empire drawing room.

1 Lady with a Parakeet, 1871. Canvas, 35⁷/8 x 25⁵/8 in.
New York, The Solomon R. Guggenheim Foundation, Thannhauser Collection.

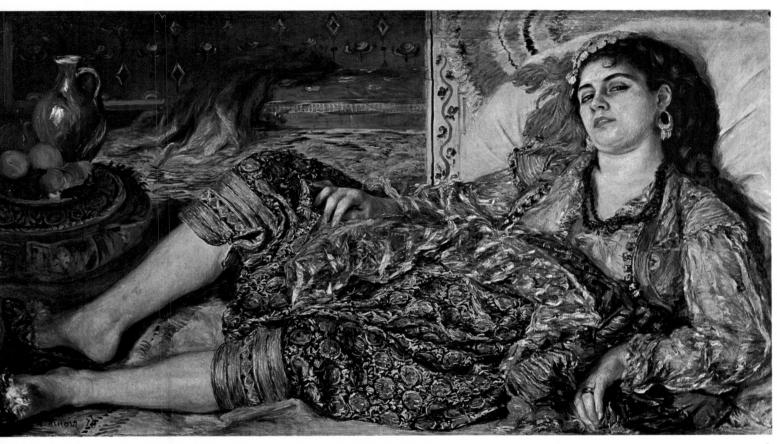

2

2 Odalisque, or Woman of Algiers, 1870. Canvas, $27 \times 48^{1/2}$ in. Washington, D.C., National Gallery of Art, The Chester Dale Collection.

ly, he is wholly absorbed in the picture he is painting.

Through Bazille, Renoir became friendly with the dilettante Edmond Maître, of Bordeaux. Occupying a modest post at the Paris prefecture, which left him much spare time, Maître was a talented musician as well as an art lover and scholar. The wide range of his erudition and his warm congeniality charmed his many acquaintances. And through him, Renoir met various other artists and writers: Fantin-Latour, Auguste de Molins, and the sculptor Philippe Solari. At Maître's apartment Renoir also met the librettist Blau and the well-known print collector Fioupou from Toulon, a

deputy clerk in the Ministry of Finance, who had much to tell him of the great and misunderstood artists of their day he had known personally, such as Delacroix and Baudelaire. Sometimes the photographer Carjat, a friend of Courbet and Nadar, came along; well-to-do and good-humored, he invariably amused their circle with his eccentric dress. Renoir and Bazille often arranged to meet in late afternoon at the Café Guerbois, in Grand'Rue des Batignolles, just a few minutes from Bazille's studio in Rue de la Condamine. There they were certain to find some of their former comrades from Gleyre's atelier and others from the Académie Suisse,

grouped around their leader and senior colleague, Edouard Manet. At the Guerbois one could also rub elbows with art critics Edmond Duranty, Armand Sylvestre, Philippe Burty, and Paul Alexis, and novelist Émile Zola and his childhood friend Paul Cézanne, or such other artists as Constantin Guys and the society painter Alfred Stevens.

The outbreak of the Franco-Prussian War on July 18, 1870, took Renoir by surprise at a moment when he was engrossed in his work. As the Prussian invasion of France began, he enlisted in a cavalry regiment and was garrisoned in southwest France, first at Tarbes in the Pyrenees, then at Libourne near

Bordeaux, where he became seriously ill. Thanks to an uncle who came to look after him, he was hospitalized in Bordeaux and soon recovered. Released on March 15, 1871. Renoir returned to Paris in early spring, during the troubled days of the Commune. Taking a room in Rue du Dragon, near the apartment of Edmond Maître, he lost no time in getting back to work. He painted two large portraits, very similar in subject and style: one of his friend's mistress Rapha, looking at some birds in a cage, and a full-length portrait of Lise Tréhot, better known as the Woman with a Parakeet.

In January 1872, when Paris had hardly begun to recover from the grave events of the previous year, and intellectual and artistic life was at a standstill, Renoir had the good fortune of meeting the dealer Paul Durand-Ruel, introduced at his Rue Laffitte gallery by Monet and Pissarro. After several cordial conversations, the future advocate of the Impressionists decided to acquire some paintings by Renoir. On March 16, 1872, he bought an early view of Paris from the young artist for 200 francs: Pont des Arts and the Institut (Norton Simon Foundation, Los Angeles). By thus showing confidence in them. Durand-Ruel thereafter associated his own career as a dealer with that of Renoir and his friends, whose efforts he courageously supported until the group finally achieved recognition and fame. At the very time when he established his relation with Durand-Ruel, Renoir was putting the finishing touches on an impressive composition, Parisian Women Dressed as Algerians. He submitted this to the Salon of 1872, but the jury rejected it. In this large exotic canvas, there are again seen the sober, lovely features of Lise Tréhot. On April 24, 1872, she married the young architect Georges Brière de l'Isle. From then on, she devoted herself to her family and never again saw the great artist whose favorite model she had been for six years.

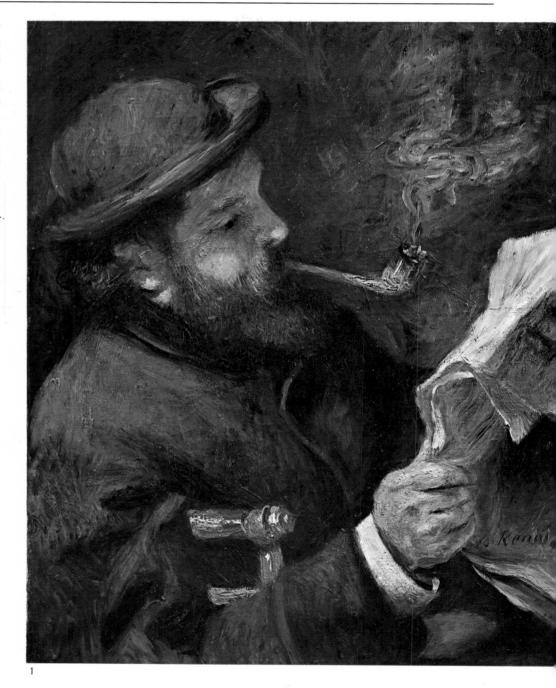

In the summer of 1872 Renoir spent several weeks at Argenteuil as the guest of Monet, in a house the latter had rented on the banks of the Seine. There Renoir painted several portraits of his artist friend and his young wife Camille. The most famous of these show Monet wearing a hat, smoking his pipe, and reading the newspaper and his wife lying on a couch for her midday

nap. Born in Lyons in 1847, Camille Doncieux became Monet's companion and model in 1865. By her he had two sons: Jean, who died before World War I; and Michel, who in 1966 bequeathed to the Musée Marmottan in Paris the collection of canvases by his father and his Impressionist friends that he had kept in the family home at Giverny.

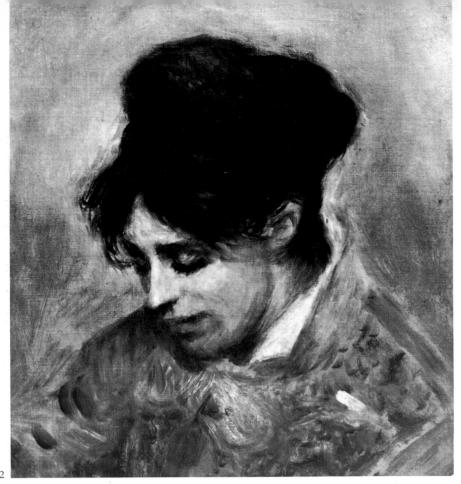

- Claude Monet Reading the Newspaper, 1872. Canvas, 24 × 19³/₄ in. Paris, Musée Marmottan. (Photo Routhier)
- Portrait of Madame Claude Monet, 1872. Canvas, 14¹/₄ × 12⁵/₈ in. Taos (N.M.), Collection of Arturo Peralto Ramos.
- 3 Madame Monet Lying on a Couch, 1872. Canvas, 21¹/₄ × 28³/₄ in. Oeiras (Portugal), Fundacao Calouste Gulbenkian.

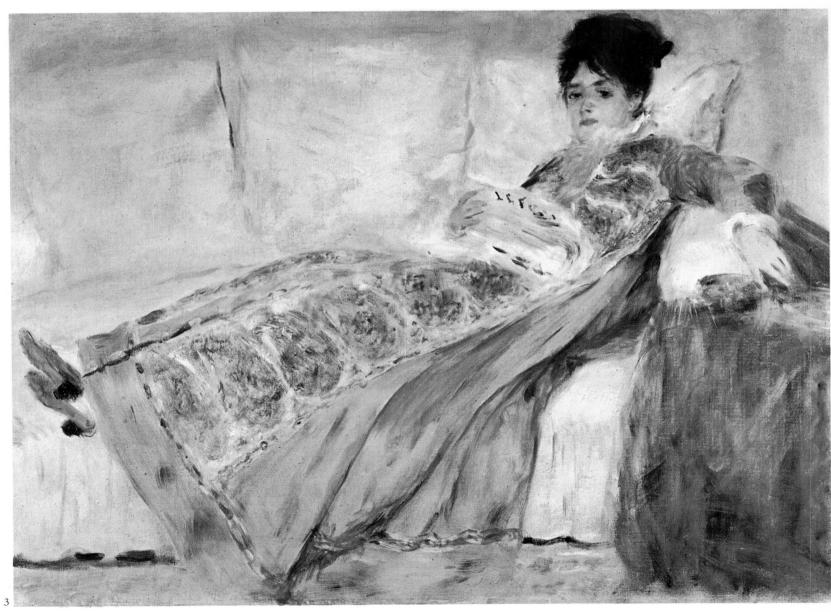

23

Through Impressionism

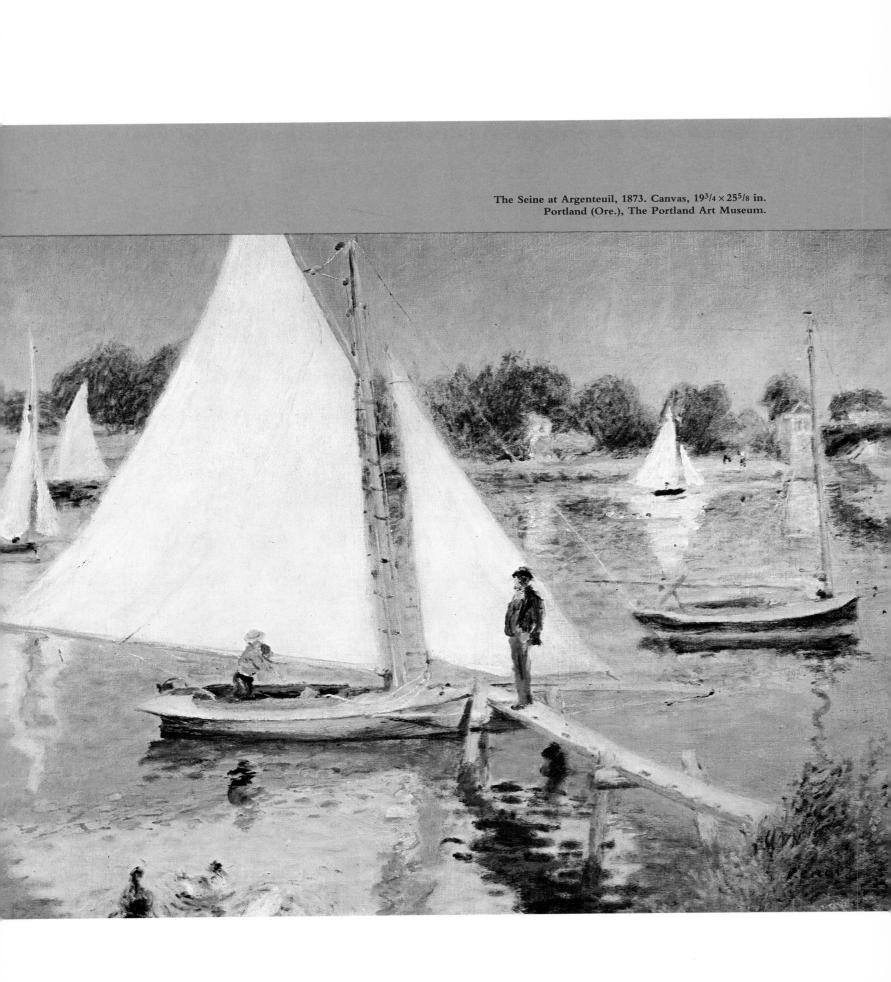

In September 1873 Renoir settled in Montmartre, where he rented an attic apartment at 35 Rue Saint-Georges. Here, in his new home, he began two canvases which he completed the following year and which were both to become famous: The Loge and The Dancer. Six months later, from April 15 to May 15, 1874, he took part in the first group exhibition of the Impressionists (who for that occasion were called "Société Anonyme des Artistes Peintres, Sculpteurs, Graveurs"), held in the Paris gallery of the photographer Nadar, at 35 Boulevard des Capucines. Renoir showed six paintings and one pastel. Unfortunately the exhibition was not a success. "The public flocked to it," related Paul Durand-Ruel in his memoirs, " but with an obvious bias, and saw in these great artists nothing but ignorant and presumptuous men trying to attract attention by their eccentricities. Public opinion then turned against them, and a general outburst of hilarity, scorn, and even indignation spread through all circles of society-the studios, salons, and even the theaters, where they were held up to ridicule." Nevertheless, three of Renoir's pictures found purchasers during the exhibition. A modest dealer, Père Martin, bought The Loge for 425 francs.

About this time Renoir began frequenting the Café de la Nouvelle Athènes, in the Place Pigalle, where the independent painters and their friends usually gathered when the day's work was done. There he met not only such older artists as Degas and Manet, but also younger painters such as Franc-Lamy, Norbert Gœneutte, and Frédéric Cordey. At the Nouvelle Athènes, Renoir also became friendly with the composer Emmanuel Chabrier, the musician Cabaner, an art-loving official at the Ministry of the Interior named Lestringuez, and a young employee in the Ministry of Finance, Georges Rivière, who was to become Renoir's biographer.

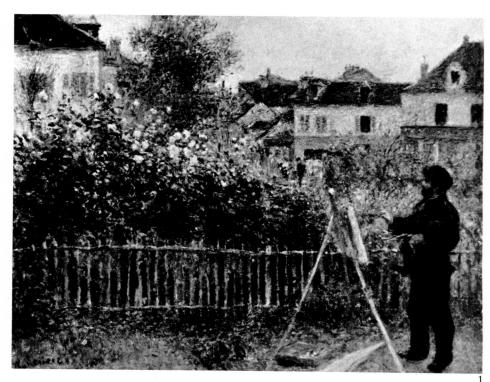

1 Monet Painting in Renoir's Garden, c. 1875. Canvas, 19³/₄×24 in. Hartford (Conn.), The Wadsworth Atheneum, Bequest of Anne Parrish Titzell.

Path in the Woods, c. 1874. Canvas, 25¹/₂ × 21⁵/₈ in.
 New York, Private collection.

In the hope of solving his financial difficulties by attracting buyers, Renoir persuaded his friends Claude Monet, Alfred Sisley, and Berthe Morisot to join him in organizing some public sales of their pictures. The first of these took place in the auction rooms at the Hôtel Drouot on March 24, 1875, and provided the opportunity for a demonstration of violent public disapprobation. The sale was a fiasco; shouts of protest greeted every bid, and the police finally had to be called in. The twenty canvases Renoir put up for sale brought only 2,251 francs, or an average of little more than 100 francs per picture. Still, though this 1875 sale was a failure, it did have one happy result for Renoir. It was there he made the acquaintance of a collector then unknown to any of

them: Victor Chocquet, a Customs functionary. "Monsieur Chocquet," as Renoir later told dealer Ambroise Vollard, "had just by chance entered the Hôtel Drouot during the exhibition of our pictures. He was kind enough to find in my canvases some similarity with the work of Delacroix, his idol. The very evening of that sale, he wrote to me, making many complimentary remarks about my painting and asking me if I would consent to do a portrait of Madame Chocquet. I accepted his offer at once." Chocquet later commissioned other portraits from Renoir, of himself, his wife, and his daughter Marie-Sophie, who died in early childhood. He became one the artist's strongest supporters and eventually bought many pictures from him.

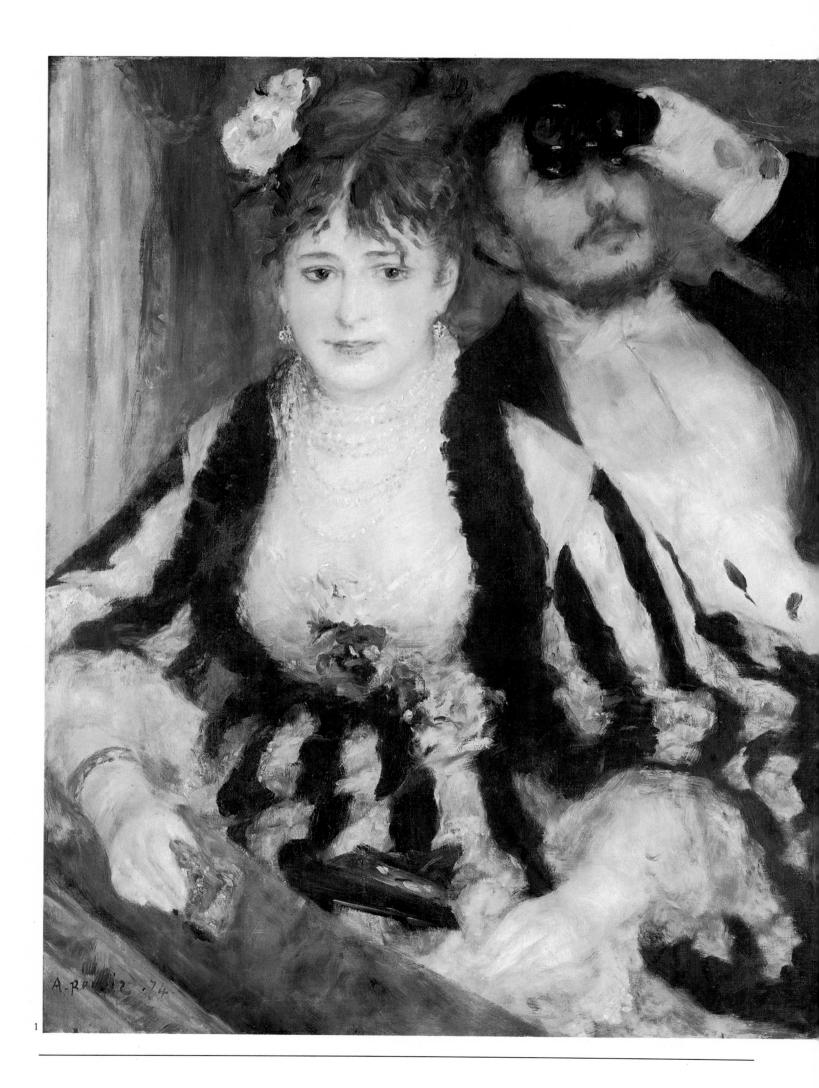

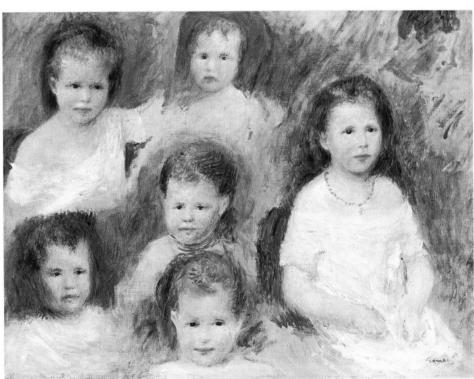

- 1 The Loge, 1874. Canvas, 32 × 25⁵/8 in. London, The Courtauld Institute Galleries.
- 2 Portrait of Victor Chocquet, 1876. Canvas, $18^{1/8} \times 14^{1/8}$ in. Winterthur, Collection Oskar Reinhart am Römerholz.
- 3 Portrait of Madame Chocquet in White, 1875. Canvas, $29^{1/2} \times 23^{5/8}$ in. Stuttgart, Staatsgalerie.
- 4 Portraits of Marie-Sophie Chocquet, 1876. Canvas, $14^{1/4} \times 17^{3/4}$ in. Cannes, Collection of Madame Florence Gould.

In April 1875 Renoir was paid 1,200 francs for a large figure composition, painted the year before, entitled La Promenade (or Mother and Children; Frik Collection, New York). With this unexpected windfall, he was able to rent two attic rooms and an old stable on the ground floor of a seventeenth-century house in Montmartre, at 12 Rue Cortot. The stable he used as a studio; he kept these quarters until October 1876. In the garden behind the house, poorly tended but charming, Renoir painted several portraits, including those of the actress Henriette Henriot, the young model Nini Lopez, and Claude Monet painting outdoors. It was here also in the peaceful garden of Rue Cortot, then on the premises of the Moulin de la Galette, that Renoir sketched out several large canvases in the spring of 1876—The Arbor, Nude in the Sun, The Swing, and Le Moulin de la Galettewhich are among his finest.

Managed by the Messrs. Debray, father and son, the Moulin de la Galette dance hall was situated on top of the Butte Montmartre, adjoining Rue Lepic. It consisted of a large, square, low-ceilinged shed, with a platform for the orchestra, and a tree-shaded garden, where a crowd of artists, students, workingmen, and pretty girls came to dance on Sunday afternoons and holidays. As soon as he had settled into his Rue Cortot flat, Renoir went ahead with his plan

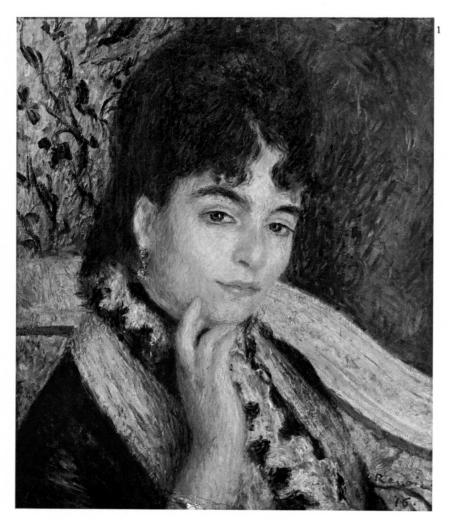

to paint a large composition showing this popular locale. He got a group of friends and models, clearly recognizable in the finished picture, to pose for him. In the foreground, sitting on a bench and wearing a striped dress, is a young model named Estelle (whose sister Jeanne had posed for The Swing); beside her are Franc-Lamy, Norbert Gœneutte, and Georges Rivière, sitting around a table with glasses of grenadine; behind them, among the dancers, are Henri Gervex, Lestringuez, and Paul Lhote. Seen in the middle distance to the left is Marguerite Legrand, known as Margot, dancing with a tall Spanish painter

in a black felt hat, Don Pedro Vidal de Solares y Cardenas. In this radiant canvas, quickly purchased by his friend the painter Gustave Caillebotte, Renoir pursued a line of visual research very similar to that of his Impressionist friends. Not only did he represent a scene of everyday life, as such painters as Boilly, Granet, Drolling, and Bonvin had done before; but, like Constantin Guys, he also succeeded in giving new vitality to a commonplace theme and in discovering, according to the wish expressed by Baudelaire, the evernew poetry of modernity. When shown at the third group exhibition of the Im-

pressionists in 1877, Le Moulin de la Galette was warmly praised by Georges Rivière in the first issue (April 6, 1877) of a small magazine called L'Impressioniste he had just founded to promote these artist friends: "It is a page of history, a precious and strictly accurate memento of Parisian life. No one before Renoir had thought of taking some everyday happening as the subject of so large a canvas. His boldness is bound to have the success it deserves. We make a point of stressing here the very great significance this picture has for the future." During his own Impressionist period (1872-1882) Renoir—like Monet, Berthe Morisot, and Sisley-applied himself to a poetic rendering of light effects, both in his nudes and in his portraits and figure groups in garden settings. While he long continued, as in such masterpieces as The Loge and The Dancer, to mix his colors on the palette and work with scumblings, he also made use (especially from 1876 on) of optical mixture: that is, juxtaposing on the canvas tiny comma-like dabs of color which then merge in the spectator's eye, while retaining their vibrant qualities. Thanks to this new method, so well suited to his own spontaneity, Renoir succeeded even in his large canvases in catching the flickering effect of the sunlight filtering through foliage or playing over the faces and clothing of his models in little white or golden

In September 1876, after finishing *Le Moulin de la Galette*, Renoir was invited to spend several weeks with the novelist Alphonse Daudet, at his summer home in Champrosay, on the edge of the Forest of Sénart. Delacroix too had spent summers at Champrosay, in the villa of the author of *Petit-Chose*, and Renoir was responsive to lingering memories of a master he revered. There was also the pleasure of daily conversation with his host, whose artistic sensibility was so close to his own. During his stay he painted a portrait of

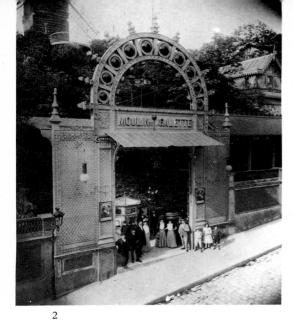

Daudet's young wife, whose face he described as "so delicate, so purely drawn."

Though still poor, Renoir was beginning to make a name for himself and by that winter his prospects were improving. The publisher Georges Charpentier, who had purchased Renoir's *Angler* at the 1875 sale, expressed a desire to meet the artist who had painted it. Invited to Charpentier's townhouse in

Rue de Grenelle, Renoir soon became a regular guest at the receptions of Madame Charpentier, frequented by the artistic and intellectual élite of Paris. In her drawing room Renoir met such politicians as Léon Gambetta and Jules Ferry, the academic painters Carolus Duran, De Nittis, and Henner, and above all the writers Edmond de Goncourt and Théodore de Banville; Zola, whom he already knew, was also to be found there. The Charpentiers soon commissioned further portraits from Renoir: first, of their children Paul and Georgette; then the celebrated one of Madame Charpentier with her daughters and their dog Porto in the Japanese

- 1 Portrait of Madame Alphonse Daudet, 1876. Canvas, $18^{1/2} \times 14^{5/8}$ in. Paris, Musée du Louvre.
- 2 Entrance to the gardens of the Moulin de la Galette. (Photo Roger-Viollet)
- 3 The Swing, 1876. Pen drawing, 6⁷/₈ × 5³/₄ in. (Illustration for "L'Impressionniste" of April 21, 1877.) Viroflay, Private collection.
- 4 The Swing, 1876. Canvas, $36^5/8 \times 28^3/4$ in. Paris, Musée du Louvre.

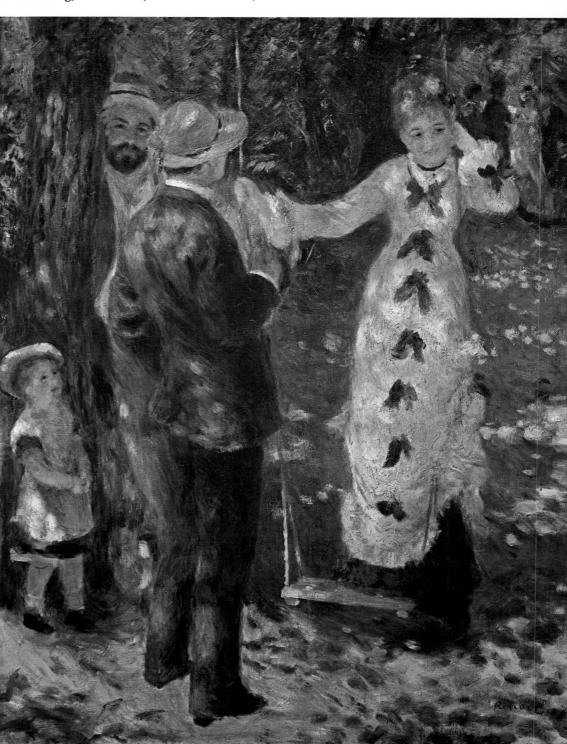

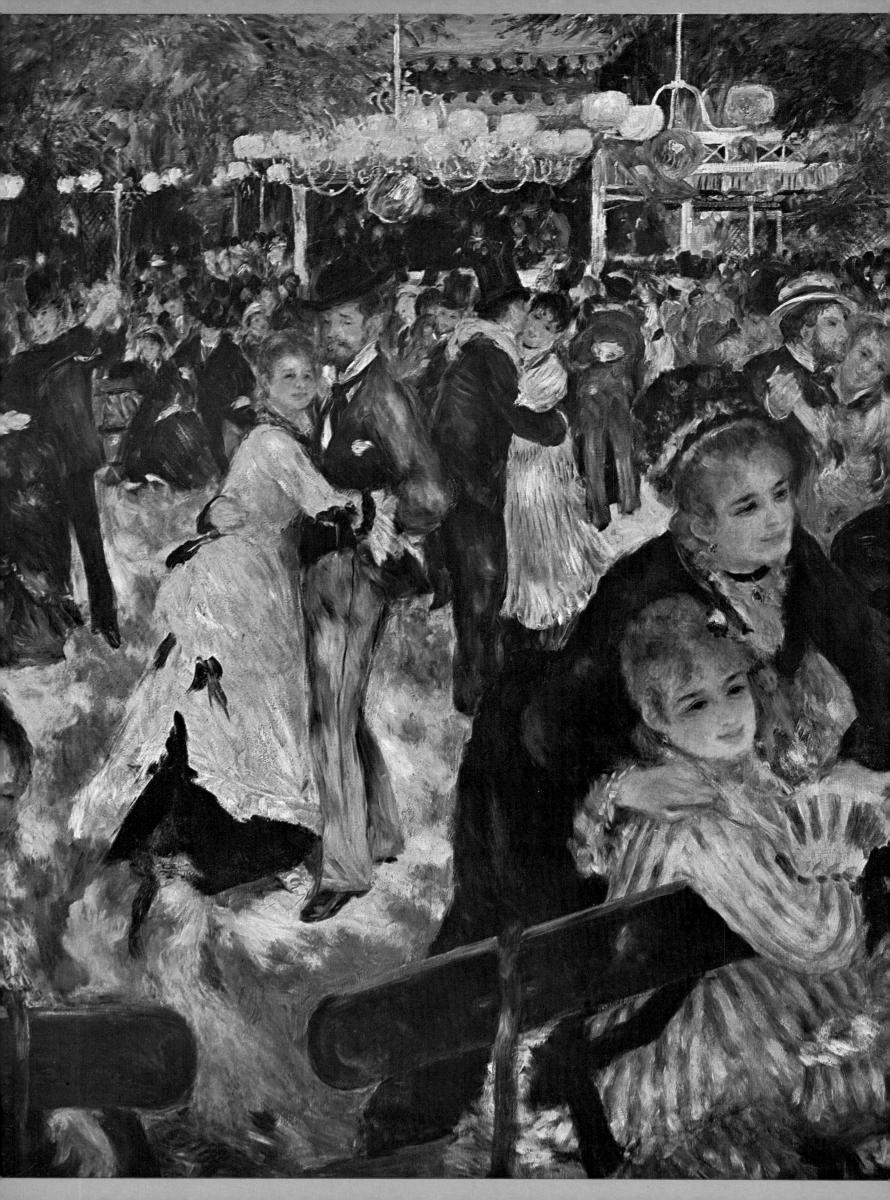

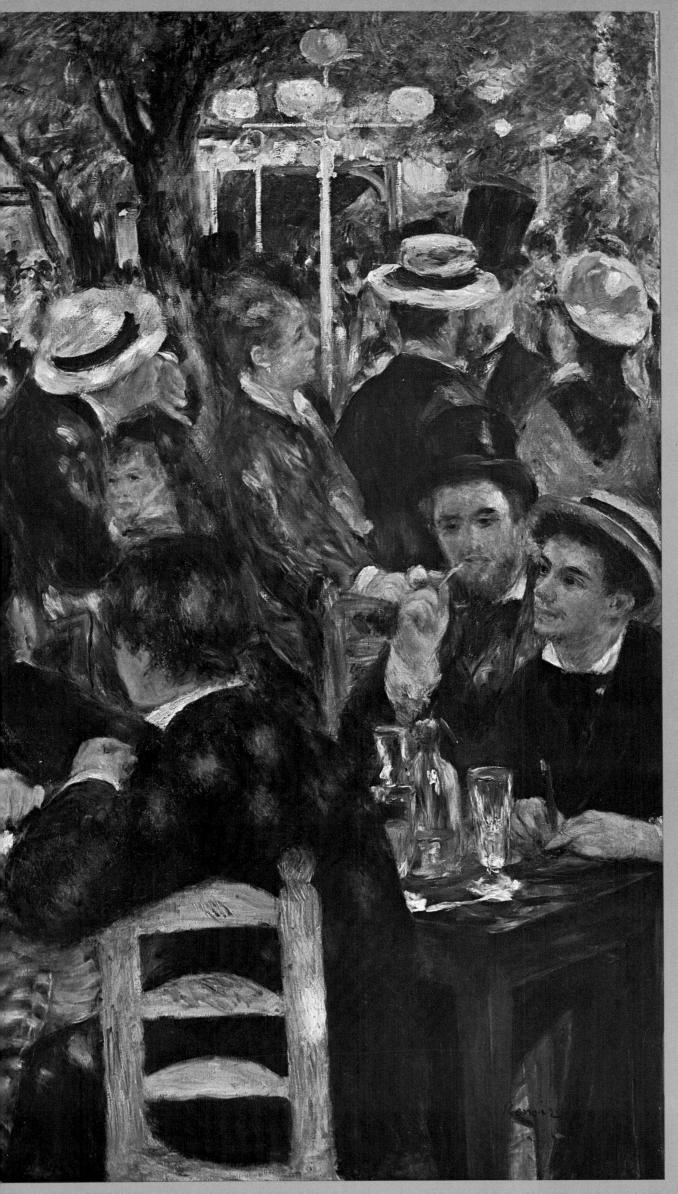

Le Moulin de la Galette, 1876. Canvas, $51^{1/2} \times 68^{7/8}$ in. Paris, Musée du Louvre.

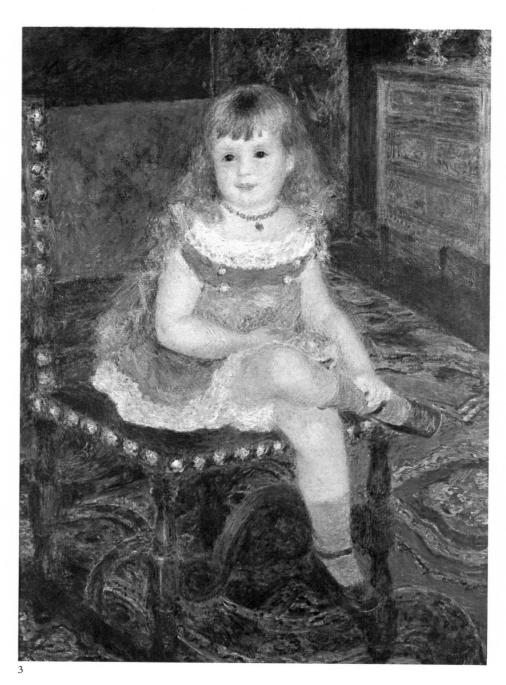

- 1 Georgette and Paul Charpentier, photograph. Paris, Robida Collection.
- The Dance, 1876. Canvas, 18¹/₈×11 in. Basel, Private collection. (Photo Paul Rosenberg & Co.)
- 3 Mademoiselle Georgette Charpentier Seated, 1876. Canvas, $38^5/8 \times 28^3/4$ in. New York, Private collection.

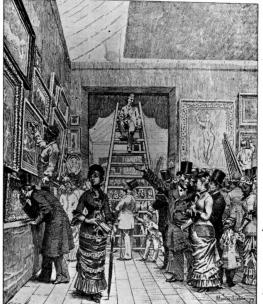

- Maurice Leloir: Vernissage at the Salon, May 11, 1879.
 Drawing reproduced in "La Vie Moderne."
 (Renoir's "Portrait of Madame Charpentier and Her Daughters" was exhibited at this Salon.)
- Madame Georges Charpentier and Her Daughters, 1878. Canvas, $60^{1/2} \times 74^{7/8}$ in. New York, The Metropolitan Museum of Art, Wolfe Fund, 1907.

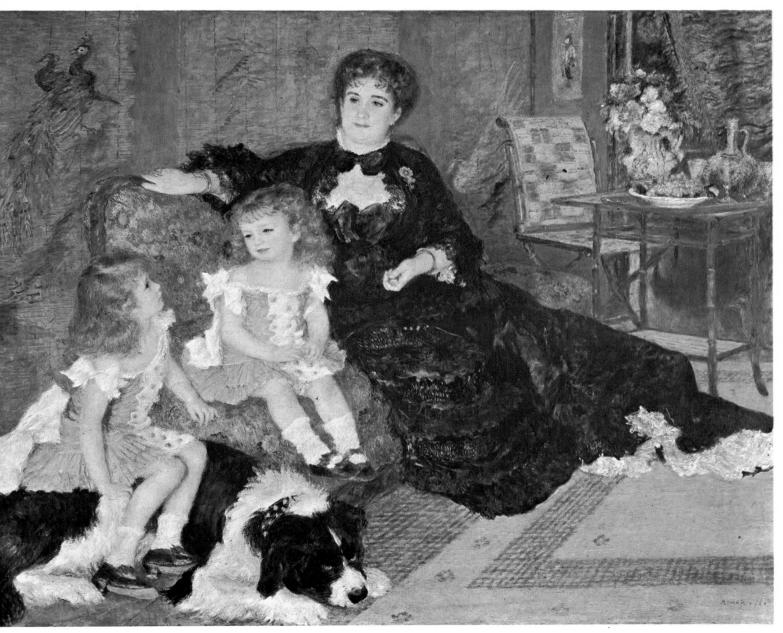

room of the family's townhouse. For this latter work, quite a large composition, Renoir required no less than forty sittings of his subjects. Thanks to the influence and connections of the Charpentiers, a canvas by Renoir was exhibited in a prime location at the 1879 Salon. Admired by the public, this was also given generally favorable notices by the critics. In his review of the Salon, published in *Le Siècle*, Jules Castagnary aptly summed up the characteristics of what he called "the enduring art" [*l'art vivace*] of Renoir: "His *Portrait of Madame Charpentier and Her Daughters* is one of the most interesting works. ... A deft and lively brush has roved over all the objects making up this charming in-

terior; through its rapid touches, these are all set out with that bright and smiling grace which creates the magical enchantment of the color." After this unexpected success, Pissarro wrote in a letter to his friend the pastrymaker Eugène Murer (May 27, 1879): "I do believe Renoir is launched. So much the better! It's so hard to be poor."

The conquest of Classicism

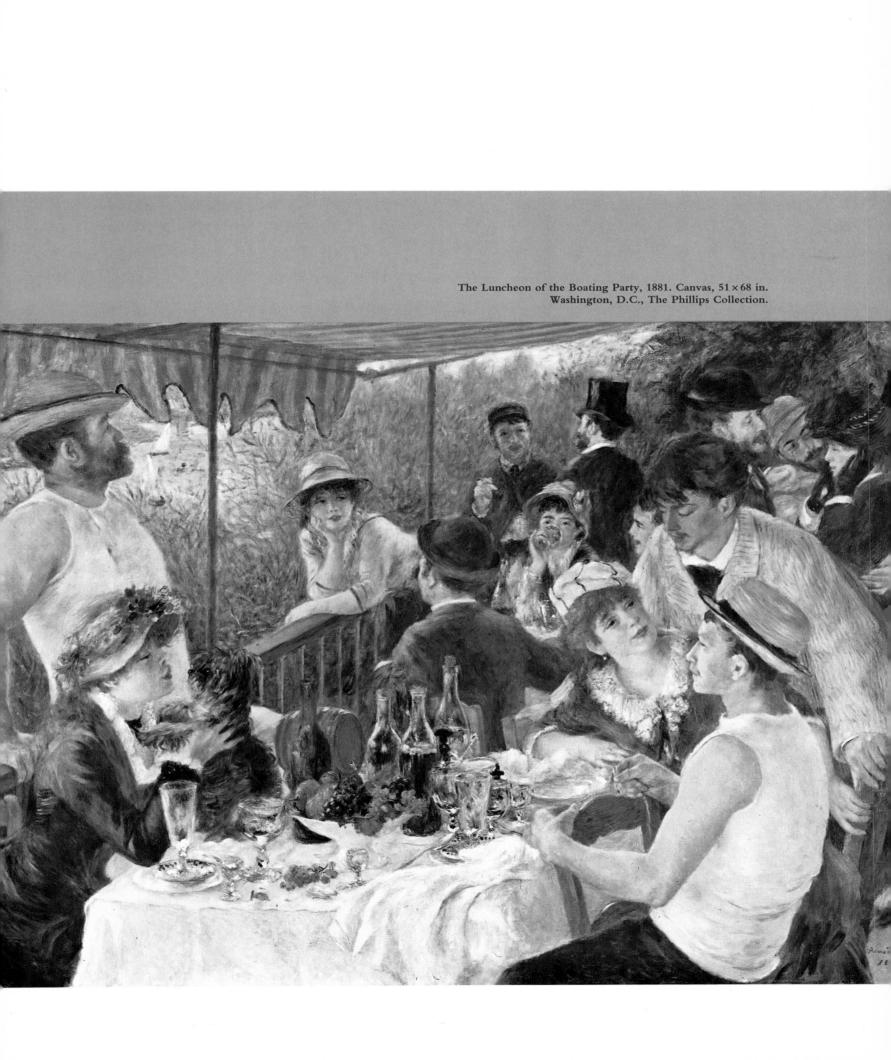

- 1 Madame Renoir with Her Dog, 1880. Canvas, $12^5/8 \times 16^1/8$ in. Paris, Private collection.
- 2 Alphonsine Fournaise on the Island of Chatou, 1879.
 Canvas, 28 × 36¹/₄ in. Paris, Musée du Louvre. (Photo Josse)
- 3 Little Blue Nude, 1879. Canvas, 18¹/₄×15 in. Buffalo (N.Y.), The Albright-Knox Art Gallery.
- 4 The Blond Bather, 1882. Canvas, $35^{1/2} \times 24^{3/4}$ in. Turin, Private collection.

When not invited to dine by the artloving pastrymaker Eugène Murer or the publisher Charpentier, Renoir usually took meals "chez Camille," a very modest restaurant in Montmartre, just across from his apartment in Rue Saint-Georges. There, in February 1880, he met a young milliner, Aline Charigot, who came from Essoyes (Aube), near Troyes.

Only twenty years old, she lived with her mother, who earned her living as a dressmaker since her husband abruptly left her and emigrated to the United States. Renoir's studio was near Madame Charigot's apartment, and Aline began coming in to pose for him. On Sundays they often went boating down the Seine to Chatou or La Grenouillère on the island of Croissy. Very soon the artist's friendship toward his young model ripened into love. Renoir admired Aline's lithe figure and graceful bearing: "She walked on the grass," he once said, "without hurting it." In the spring of that year he painted her, with her pretty but irregular features and upturned nose, wearing a straw hat and holding a bouquet, as she sat in a meadow with her dog.

During the summer of 1880 Renoir spent much time at Chatou, staying at the inn of Père Fournaise; situated on the banks of the Seine, it was frequented by amateur boatsmen and their girlfriends. In the previous year he had painted a delightful portrait of the innkeeper's daughter Alphonsine, sitting on the restaurant terrace overlooking the river. Using this same setting, he now started a large canvas which, he hoped, would equal and even surpass Le Moulin de la Galette. To his friend Paul Bérard he wrote: "I couldn't resist the urge to get rid of all background decoration, and I am doing a picture of a boating party that I've been itching to do for a long time. I'm not getting any younger, and I didn't want to delay this little feast, for later I won't be up to the effort; it's hard enough already. ... It's a good thing from time to time to at-

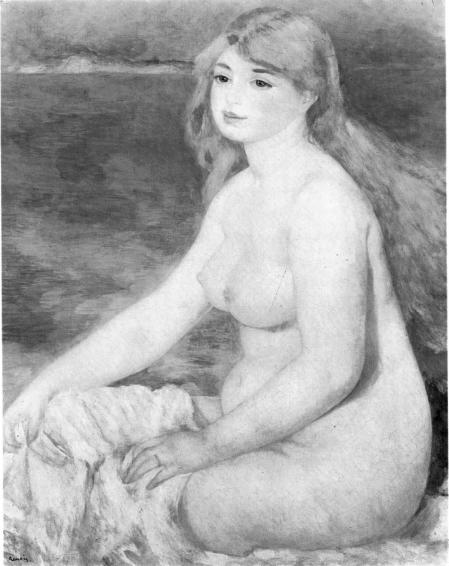

tempt something beyond one's powers."

He set to work outdoors, on the shady terrace of the Fournaise restaurant, on the Luncheon of the Boating Party, the ambitious picture he had been dreaming of, and he finished this in his studio in the winter of 1880-1881. The group represented here has just concluded a convivial meal. Around the innkeeper can be recognized many of Renoir's friends and his models: Baron Barbier, the journalist Maggiolo of Le Triboulet, the financier Charles Ephrussi, Paul Lhote and Lestringuez, and also the beautiful Angèle and the actresses Ellen Andrée and Jeanne Samary. In the left foreground, sitting at the table which has not been cleared off, is a young woman holding a puppy. Her sprightly face attracts the eye at once—it is Aline Charigot, soon to become Renoir's wife.

In the autumn of 1880 Renoir's financial worries were alleviated as if by magic. By then he had become widely known as an accomplished portrait painter. "I began one portrait this morning," he wrote to his benefactress Madame Charpentier. "I begin another tonight, and after that probably a third." Through the diplomat Paul Bérard, Renoir was introduced to the banker Georges Grimprel, who commissioned him to do portraits of his son and two daughters. At the home of Charles Ephrussi he met Monsieur Cahen d'Anvers, who asked him to portray his daughter Irène, with her vivid reddish

During his stay in Naples in the winter of 1881-1882, Renoir painted a young woman in the nude at the seaside, the Blond Bather. This fine canvas marks the beginning of his "harsh" [aigre] period. On returning to Paris, he gave it to his friend the diamond-cutter Henri Vever. It was so much admired that, at Durand-Ruel's request, in the spring of 1882 he painted a replica of it, with all the beauty of the first aversion. In the rich glow of her pink and white flesh and her opulent form delineated by pure outlines, this radiant young woman recalls the finest nudes of Ingres and heralds those of Maillol. "As for me," said Renoir, "my concern has always been to paint figures as if they were some splendid fruit."

1 Algerians, 1882. Canvas, 13³/₄ × 15³/₄ in. Algiers, Musée des Beaux-Arts. (Photo Giraudon)

hair. Then, on the recommendation of Théodore Duret, Monsieur Turquet, a former Under-secretary of Fine Arts, commissioned him to paint his wife and daughter in evening dress, as if attending a première in their box at the theater. Tired of Paris and wishing to "renew his vision," in February 1881 Renoir suddenly decided to leave for Algeria with his friend the painter Frédéric Cordey. Shortly after their arrival in North Africa, a region that had delighted Delacroix in the 1830s, the two artists were joined by Lestringuez and Paul Lhote. "I wanted to see what the land of sun was like," wrote Renoir to Théodore Duret on March 4, 1881. "I am out of luck, for there is scarcely any at the moment. But it is exquisite all the same, an extraordinary wealth of nature." During this first visit to Algiers—which lasted nearly a month —and during a second visit a year later, Renoir painted several figures of Algerian women, some landscapes, in particular Grove of Banana Trees and The Ravine of the Wild Woman, and above all some studies of Arab types in the Casbah.

When he returned from North Africa, Renoir did not stay in Paris long. Restless and dissatisfied with himself and his art, he left on a journey to Italy at the end of October 1881. Passing through Milan, he stopped off in Venice, where he painted the Basilica of St. Mark's and some gondolas on the Grand Canal. "I did the Doges' Palace as seen from San Giorgio, just opposite," he wrote to Charles Deudon. "I don't think this was ever done before. There were at least six of us painting it, one behind the other!" From Venice he went off to Florence, where he marveled at Raphael's Madonna della Sedia in Palazzo Pitti. Then he went south to

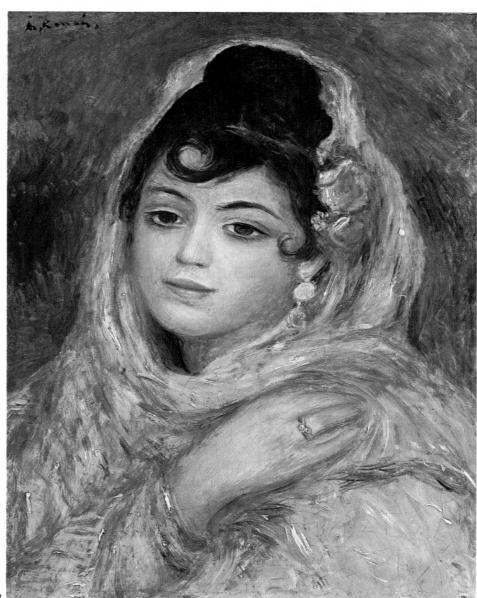

2 Algerian Woman, 1881. Canvas, 15³/₄ × 12⁵/₈ in.
New York, The Solomon R. Guggenheim Foundation, Thannhauser Collection.

During his two visits to Algiers in 1881 and 1882, Renoir painted some Arab girls, some studies of natives, a young boy named Ali, and also a Frenchwoman in exotic costume. "Here I am, installed nearby Algiers," he wrote to Durand-Ruel in March 1882, "and negotiating with some Arabs to find models. ... I have seen some extraordinarily picturesque children. ... I have also seen some very pretty women." The Algerian Woman of the

Thannhauser Collection is one of those most attractive women. In its elegant flowing lines, this portrait points toward Renoir's subsequent "Ingresque" period. With a few telling curves, the painter makes us feel the indefinable radiance of the young Algerian girl's face, capturing the large dark eyes, the contrast between her compelling gaze and her faintly smiling mouth, the naturalness of gesture as she carelessly throws a veil over her shoulders.

- 3 Portrait of Richard Wagner, January 11, 1882. Canvas, 20^{1/2} × 17^{3/4} in. Paris, Musée du Louvre. (Photo Musées Nationaux)
- Venice, Fog, 1881. Canvas, 17³/₄ × 24³/₄ in.
 Washington, D.C., Mr. and Mrs. David Lloyd Kreeger.
- Venice, St. Mark's, 1881. Canvas, 25¹/₂ × 31⁷/₈ in.
 Minneapolis, The Minneapolis Institute of Arts.

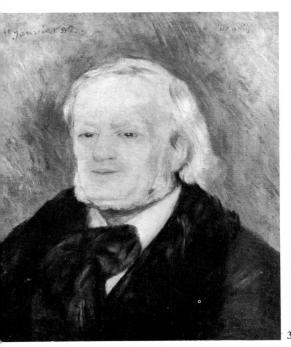

Rome to study the Farnesina frescoes and the Vatican Stanze. On November 21, 1881, now staying at the Albergo della Trinacria in Naples, he wrote Paul Durand-Ruel a long letter that did not conceal the anxiety he felt about his work: "I am like a schoolchild, with the white sheet of paper in front of him on which he must try to write neatly. Then, bang! A blot of ink. I am still struggling with these blots, and I am forty years old. I have been to see the

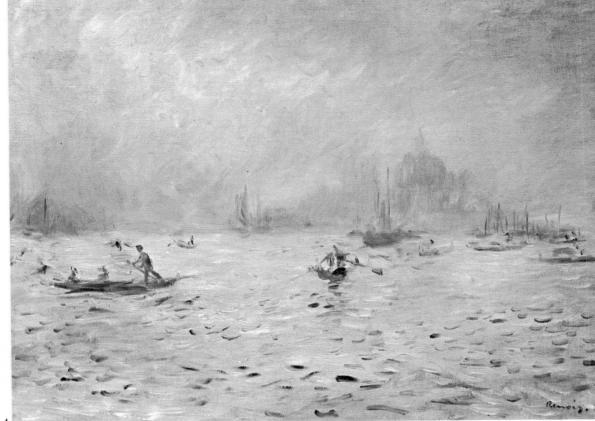

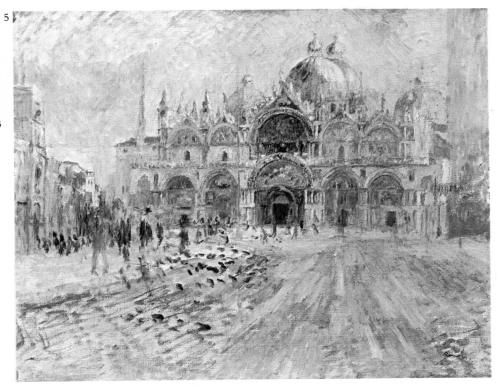

In the autumn of 1882, again at Durand-Ruel's request, Renoir set to work on two matching pictures on the theme of the dance—one in town, the other in the country. As Jean-Louis Vaudoyer has aptly noted, "Here, instead of two models passively posing, we have two human beings living a memorable moment in their lives." For the first picture (Fig. 3), Renoir's future wife Aline Charigot posed with his friend the painter Paul Lhote. For the second (Fig. 4), Paul Lhote again posed, but this time with a young acrobat from the Cirque Molier named Maria Clémentine—later a well-known painter on her own under the pseudonym Suzanne Valadon.

- 1 Portrait of Charles and Georges Durand-Ruel, 1882. Canvas, 25⁵/8 × 31⁷/8 in. Paris, Durand-Ruel Collection.
- 2 Dancing in the Country, 1883. Pen drawing, 19¹/₄ × 12¹/₄ in. Los Angeles, Collection of Mr. and Mrs. Norton Simon.
- 3 Dancing in the Country, 1883. Canvas, 70⁷/₈ × 35¹/₂ in. Paris, Durand-Ruel Collection.
- 4 Dancing in Town, 1883. Canvas, $70^{7/8} \times 35^{1/2}$ in. Paris, Durand-Ruel Collection.

Raphaels in Rome. They are truly fine, and I should have seen them sooner. They are full of learning and wisdom. Unlike me, he was not looking for impossible things, but it is very beautiful." In December he visited Calabria, Pompeii, and Sorrento. He also stayed at Capri, where he painted several nudes and one masterpiece, the *Blond Bather*, done while in a fishing boat on the brilliantly sunlit bay.

On January 12, 1882, Renoir left Naples for Sicily, where he hoped to do a portrait of Richard Wagner, to fulfill a commission given him by a Paris friend,

Judge Lascoux of the Court of Appeals, who was a great music-lover. After a rough crossing he reached Palermo, where Wagner was living at the Hotel delle Palme and had just put the finishing touches on the score of *Parsifal*. On January 15 he granted the artist a brief interview, and in thirty-five minutes Renoir painted an arresting portrait of the composer. When the sitting was over, Wagner asked to see the still-wet canvas: "Ah! Ah!" he exclaimed, "I look like a Protestant minister." On his way home from Italy, Renoir stopped at Marseilles and went out to

spend a few days at L'Estaque, staying at the Hotel des Bains. On January 23, 1882, he wrote to Durand-Ruel: "I have been to L'Estaque, a small place like Asnières, but at the seashore. Because it is very fine country, indeed, I mean to stay another fortnight. It would really

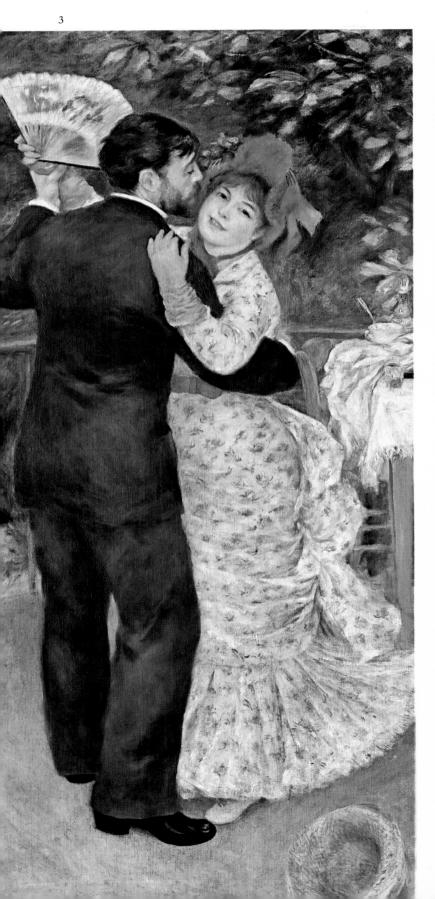

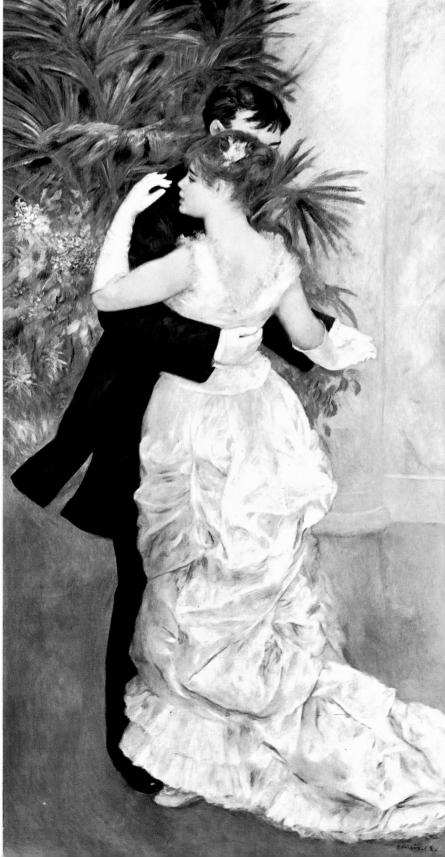

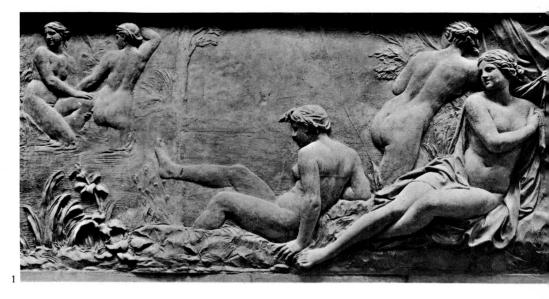

In 1882 Renoir conceived the idea of painting a large figure composition showing a group of playful women bathers, some sitting on the riverbank, others standing in the water. Begun on his return from Italy, and long and carefully thought out, the celebrated Large Bathers (p. 47, Fig. 3) was not finished until the spring of 1887; it was exhibited at the Salon that same year. For the overall design, Renoir is known to have taken inspiration from the lead bas-relief Nymphs Bathing (Fig. 1), by François Girardon, which adorns the ornamental pond of the helonging to the painter Jacques-Émile Blanche, the Large Bathers was purchased in 1928 by the American collector Carroll S. Tyson and was bequeathed to the Philadelphia Museum of Art at his death.

Before laying out the final version of his Large Bathers, Renoir painted two oil sketches of it (p. 45, Fig. 3; p. 46, Fig. 1); he also made numerous drawings of the overall composition and many studies of details, all of which have unexpected tactile qualities and linear precision. It is worth looking at these carefully to help understand the painter's working methods. Before starting his large canvas, Renoir executed a whole series of pencil and red chalk drawings in the spirit of his subject. Whether these stress a single figure (p. 45, Figs. 1,2; p. 46, Fig.2) or the group (p. 44, Figs. 2,3), Renoir considered them necessary preliminary exercises for the ambitious finished work. In his experiments he had noted that some forms well suited to the small format of a sheet of sketching paper did not lend themselves to the larger dimensions of a canvas or a fullscale cartoon. For this reason, he did not use the method of squaring off sketches done directly from nature for eventual enlargement on canvas but, instead, preferred to make large-sized drawings straight away, which could then be transcribed to canvas. This is how he proceeded for the final version of the Large Bathers.

After visiting Renoir in his Rue Laval studio, Berthe Morisot made these revealing remarks in her notebook on January 1, 1886: "It would be interesting to show all these preparatory studies to a public which generally assumes the Impressionists work at top speed. I do not believe that one could go any further in rendering form in a drawing. These nude women going into the sea delight me quite as much as those of Ingres. Renoir tells me that the nude is for him one of the indispensable forms of art."

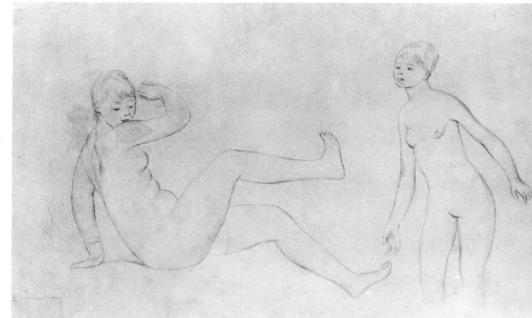

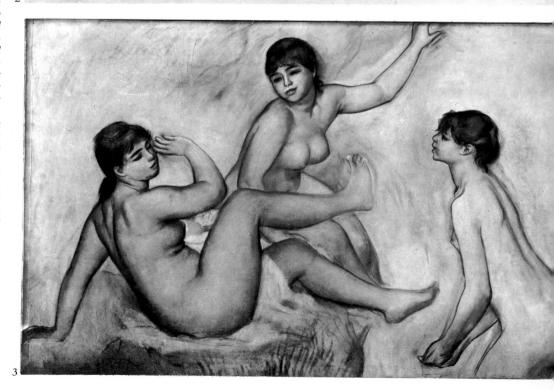

- 1 François Girardon (1628-1715): Nymphs Bathing. Bas-relief. Versailles, Bassin de l'Allée des Marmousets. (Photo Giraudon)
- 2 Two Bathers, 1884-1885. Pencil drawing, 105/8×17 in. New York, Private collection.
- 3 Three Bathers, 1884-1885. Pencil drawing, 421/2×64 in. Paris, Musée du Louvre. (Photo Giraudon)

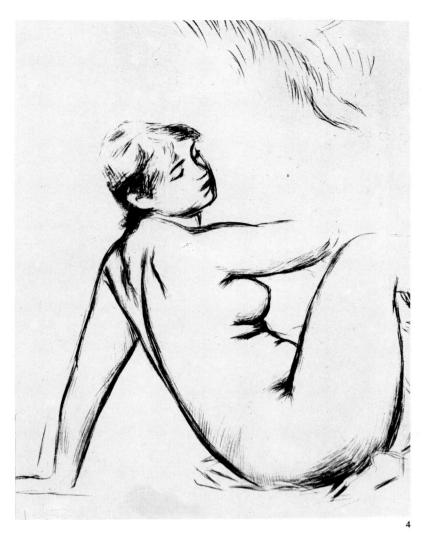

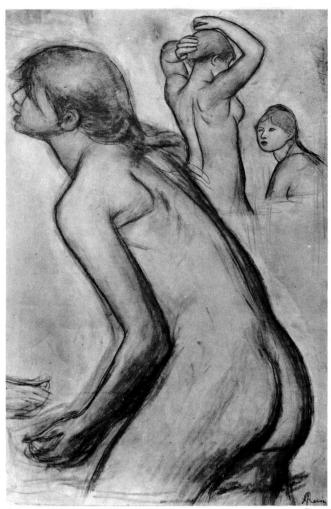

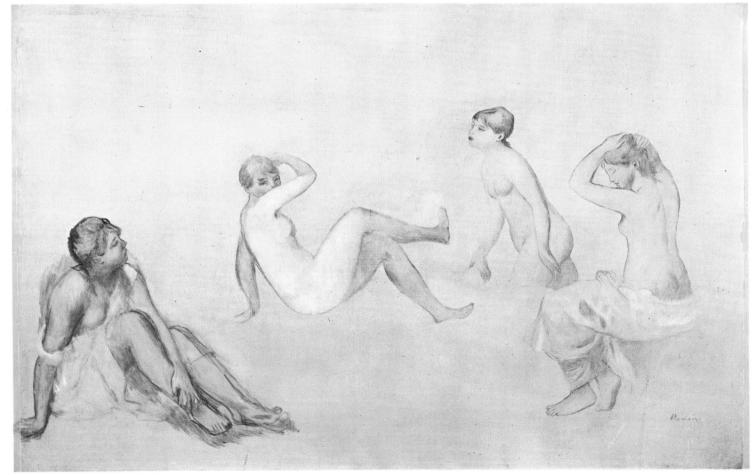

- 4 Study for "The Large Bathers" (detail), 1885. Pen drawing, $12^{5/8} \times 9^{7/8}$ in. Paris, Private collection.
- 5 Study for "The Large Bathers," 1885. Red chalk, 311/2×235/8 in. Paris, Private collection. (Photo Robert Schmit)
- 6 Sketch for "The Large Bathers," 1884-1885. Canvas, 241/2×371/2 in. Paris, Paul Pétridès Collection.

- 1 The Large Bathers, 1885-1902. Canvas, 451/4×66 in. Nice, Musée Masséna.
- 2 Study for "The Large Bathers," c. 1884. Pencil and red and white chalk, $38^{1/2} \times 25^{1/4}$ in. Chicago, Courtesy of The Art Institute of Chicago.
- 3 The Large Bathers, 1887. Canvas, $45^{1/2} \times 66$ in. Philadelphia, The Philadelphia Museum of Art, Mr. and Mrs. Carroll S. Tyson Collection.

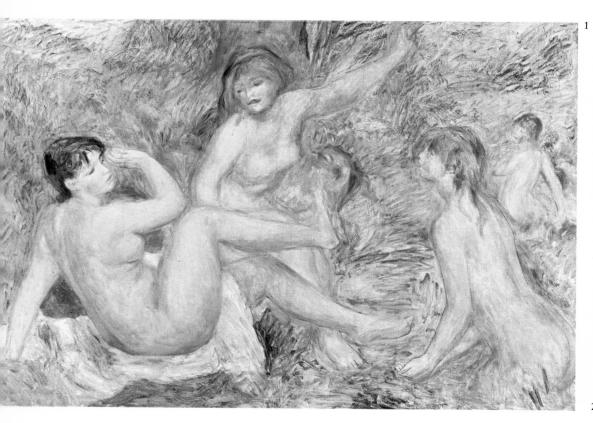

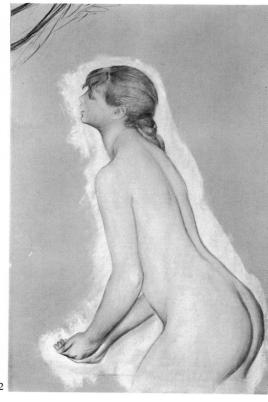

be a pity to leave this lovely spot without having something to show for it, and what weather we're having! Springtime with a mild sun and windless days, which is unusual for Marseilles. What is more, I have run into Cézanne and we are going to work together." Unfortunately, while working there outdoors, Renoir caught a bad cold which developed into pneumonia. Invigorated by the mild climate of the

Riviera, he was soon fit again and able to return to Paris. There a joyful reunion took place with Aline, who had patiently awaited him, and very likely in May 1882 they decided to set up house together. About this time, too, Renoir executed a second version of the *Blond Bather*, at the request of Paul Durand-Ruel, who soon sold it to Paul Gallimard. This was followed by portraits of the five Durand-Ruel children. In au-

tumn he sketched two large figure compositions on the theme of the dance—one in the country, the other in the city. But it was not until early in 1883 that he was able to complete them.

These paintings mark the beginning of his Ingresque period (1883-1887), which Renoir also called his *manière aigre* ("harsh manner"). "About 1883 a kind of break occurred in my work. I had got to the very end with Impressionism, and

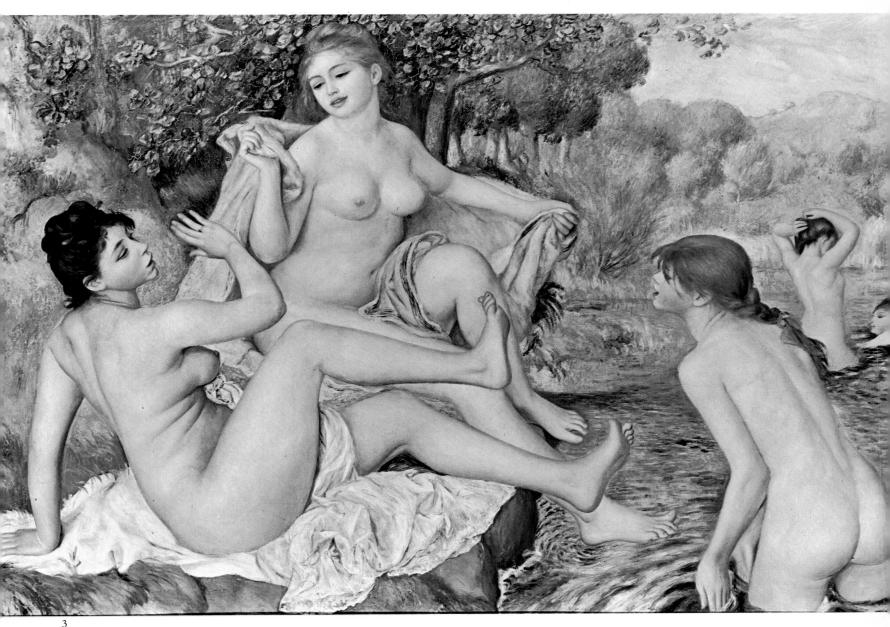

came to the realization that I didn't know how to paint or draw. In a word, I had come to a deadlock." This statement made to Ambroise Vollard, who became for Renoir something of what Eckermann had been to Goethe, is highly significant; for, after his journey to Italy, where he discovered the archaeological treasures of Naples and the murals of Pompeii, and especially after

pondering the early Renaissance *Treatise* on *Painting* by Cennino Cennini, Renoir went through an extremely critical period. First of all, he realized instinctively that it was a danger to work in the open air, directly from nature (*sur le motif*). "Outdoors," he said, "you have a greater variety of light than with studio lighting, which is always the same. But outside, for that very reason,

you are so taken by the light that you don't have time to pay enough attention to composition, and so you don't really see what you are doing." Indeed, to attempt to capture a fleeting instant in the endless flux of nature is an impossible wager. The aspect of the model

¹Ambroise Vollard, *Renoir*, Paris, 1919, p. 135. ²*Ibid.*, p. 135.

 Motherhood (Madame Renoir and Her Son Pierre), 1885.
 Pencil drawing, 4¹/₈ × 3 in. Paris, Private collection.

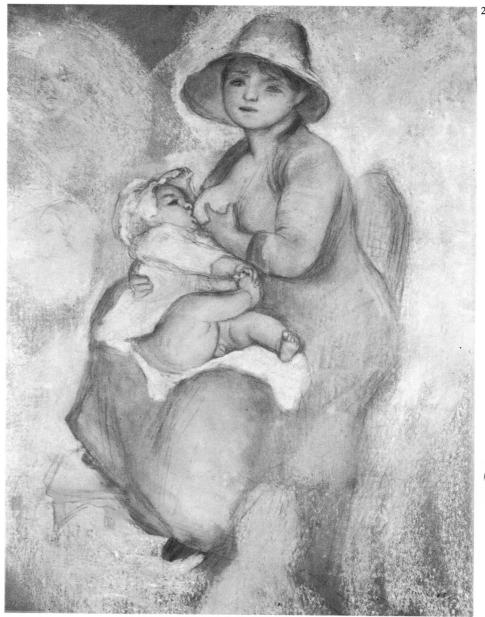

changes, the sun shifts, the clouds pass on, or the leaves on the trees tremble. Even more—and Renoir was strongly conscious of this—the continuous practice of plein-air painting led inevitably to a suppression of form and draftsmanship; paradoxically, it produced insubstantial effects.

For all these reasons, Renoir determin-

ed to make a fresh start under the inspiration of the old masters. In his new apprenticeship, he chose as guides the Raphael of the Farnesina frescoes and the Ingres of *La Source* and the *Portrait of Madame Rivière*. So, abandoning his previous ideals, Renoir turned from rendering atmosphere and light to aim now at style and precision of line. Fear-

- Motherhodd, 1885. Red chalk with touches of white chalk, 29¹/₂ × 21¹/₄ in. London, Private collection.
- 3 Motherhood, 1916. Bronze, height 21¹/₄ in. Paris, Collection of M. Alex Maguy.
- Motherhood, 1885. Pen drawing, 10¹/₄ × 7¹/₂ in. London, Private collection.

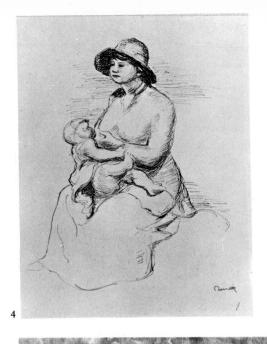

Motherhood, or Woman Nursing Her Child, 1886. Canvas, $32 \times 25^{1/2}$ in. New York, Private collection.

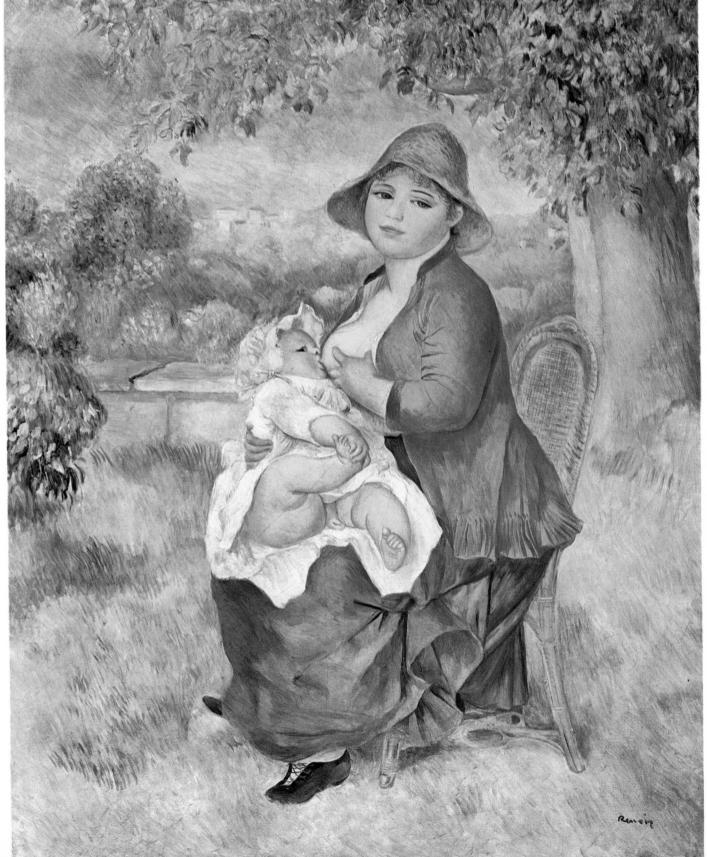

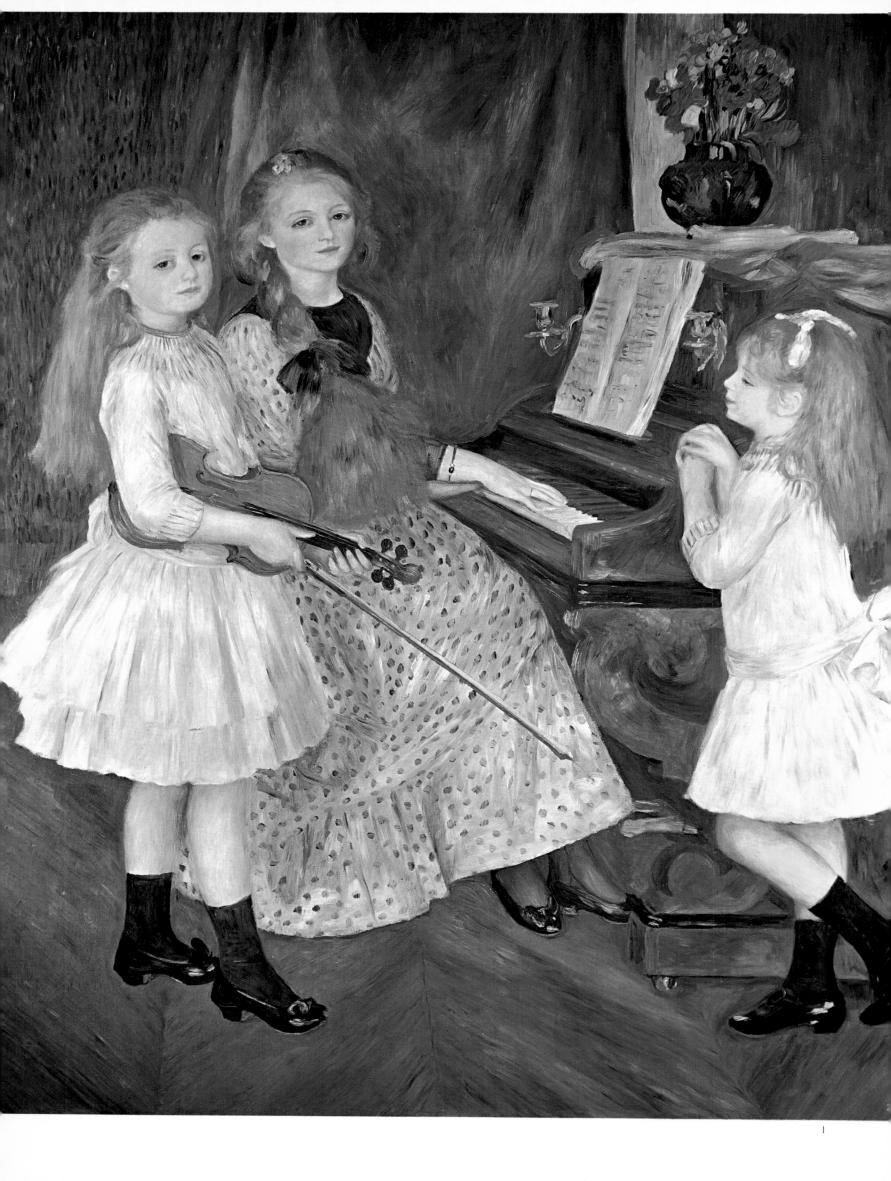

- The Daughters of Catulle Mendès, 1888. Canvas, $64^{1/4} \times 51^{1/4}$ in. London, Collection of The Hon. and Mrs. Walter H. Annenberg.
- Pierre Renoir Drawing, 1888. Canvas, $10^{1/4} \times 13^{3/8}$ in. New York, Private collection.
- Renoir in a photograph of about 1890. Paris, Collection of Madame Ernest Rouart.
- List of colors on Renoir's palette.

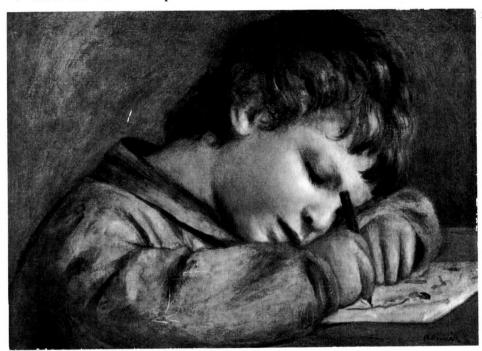

ing he had given way too readily to facility and grace, he imposed on himself a severe discipline. The two versions of the Blond Bather, Girl with a Swan, Girls Playing at Shuttlecock, and above all the pencil and red chalk drawings and the many variants in oils of the Large Bathers are characteristic of his new manner. In these works a single outline often suffices the artist to make us aware of the weight of a breast, the slight flexing of a hip, the curve of an arm, or the torsion of a body as it straightens up. With consummate art Renoir succeeded in uniting purity and sensuousness.

When his young wife was expecting their first child, Renoir went to look for

for himself and an apartment for his family. The former was at 37 Rue Laval (now Rue Victor Massé); the apartment, comprising four rooms and a kitchen, was at 18 Rue Houdon. There, on March 21, 1885, was born the artist's eldest son, Pierre. From then on, Renoir devoted himself to family life, and limited his horizons more and more to his home and his work. This point was well made by Jean Renoir in his book about his father: "More important than [artistic] theories, I think, was Renoir's transition from bachelorhood to being a married man. Restless, incapable of staying in one place, he would suddenly jump on a train with the vague hope of enjoying the soft light of Guernsey or losing himself in the pink reflections

Helyone, who in 1898 married the novelist Henri Barbusse, author of Le Feu. Since Mendès was not well off, he could only give the artist a hundred francs for this large canvas, now regarded as one of Renoir's masterpieces. In 1890 it was exhibited at the Salon, where he had not participated since 1887, for Renoir was by then considered a revolutionary painter.

more comfortable accommodations and, in the autumn of 1883, rented a studio One of the most popular French poets of his day, Catulle Mendès married a talented composer, Augusta Holmes. In 1888 he asked Renoir to paint a portrait of his three daughters grouped around the piano in his drawing room. From left to right: the poet's second daughter Claudine, holding a violin (later married to Mario de la Tour Saint-

Ygest, a disciple of Lecomte de Lisle); then the eldest sister

Huguette, seated at the keyboard; and finally the youngest,

Jame de Chrôme de naples. Ocre Jaune. Verre de Leeure naturales -Vermillon a que de farance Wert de Cobaldt Bleu Olen Outremen l'our Jame le Jame le Naple, et la terre de Diene ne sont que de tous intermédicies. Jour

- The Apple Vendor, 1890. Pencil drawing, 18⁷/₈ × 20⁷/₈ in.
 New York, Private collection.
- Little Girl with Sheaf of Grass and Wildflowers, 1888.
 Canvas, 25⁵/8 × 21¹/4 in. Sao Paulo, Museu de Arte.
- The Apple Vendor, 1890. Canvas, 25⁵/8×21¹/4 in.
 Cleveland, The Cleveland Museum of Art, Leonard C. Hanna, Jr., Collection.
- 4 In the Meadow, or Gathering Flowers, 1890. Canvas, 31⁷/₈ × 25⁵/₈ in. New York, The Metropolitan Museum of Art.

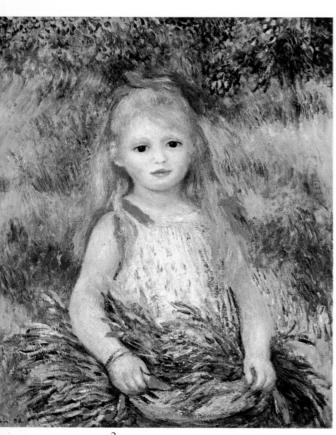

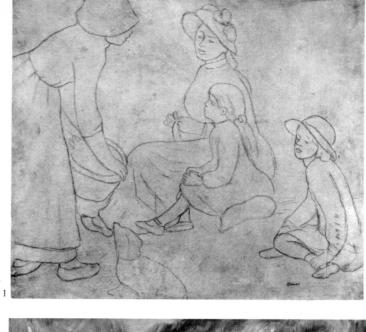

The different versions of Motherhood, dating from 1885 and 1886, are typical of this new orientation of Renoir's art. Here, with incomparable charm and naturalness, he presented his young wife, in a voluminous blue skirt and with a straw hat on her head, nursing her infant son Pierre on a bench in the garden of Essoyes. This picture is full of softly rounded volumes; mother and child are like ripe ears of corn or some heavy fruits ripening under a summer sun. Renoir was so fond of this fine

During the summer and autumn of 1890, Renoir often painted rustic scenes, evoking the charm and simplicity of everyday life in the countryside. In the different versions of The Apple Vendor, he has given us a lively glimpse of his young wife, his first-born Pierre, and his nephew Edmond Renoir, Jr., all of them seated on the grass. In Gathering Flowers, the painter presents two summer visitors to the country resting for a moment on the grass. With their long hair, light frocks, and beribboned hats, the two little girls merge wonderfully into the light-drenched landscape.

1 Jean Renoir, Renoir, Paris, 1962, p. 243.

Louis Jouvet, became one of the leading French actors in the period between the World Wars.

In that same year (April 1888), Renoir painted a portrait of the three daughters of the poet Catulle Mendès, grouped around the piano in their drawing room. For this large, fine commissioned portrait, the artist was grossly underpaid; but fortunately, from this time on, he

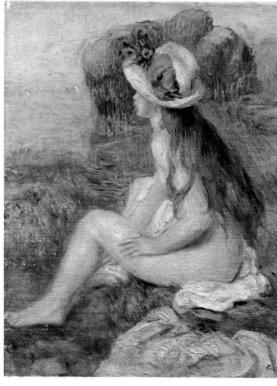

series of paintings, pastels, and red and black chalk drawings showing Aline with their first child that thirty years later, in 1916, he asked the sculptor Richard Guino to execute for him a piece of sculpture on this same theme, done under his personal supervision. Of his first child, Renoir has left several portraits of delightful freshness. After the constraints involved in executing portrait commissions that did not always appeal to him, he was now happy to paint a baby boy in perfect

freedom and to catch the fleeting expressions on his face. A particularly tender example is the 1888 picture of little Pierre, aged three, trying with plump fingers to draw on a sheet of white paper. Comparing this portrait with photographs of Pierre Renoir taken years later at the peak of his career, one can judge the scrupulous honesty of the artist in the treatment of his model. In this chubby-cheeked boy with dreamy eyes and an expressive brow, one recognizes already the man who, with

- Girls by the Seaside, 1894. Canvas, 21⁵/8 × 18¹/8 in.
 Fribourg (Switzerland), Collection of Baron Louis de Chollet.
- Nude with Straw Hat, 1892. Canvas, 16¹/₈ × 12⁵/₈ in.
 Paris, Private collection.
- 3 Portrait of a Girl, c. 1890. Red Chalk, 17³/8 × 13³/4 in. Paris, Private collection.
- Bather Sitting on a Rock, 1892. Canvas, 31⁷/8 × 25⁵/8 in.
 Paris, Private collection.

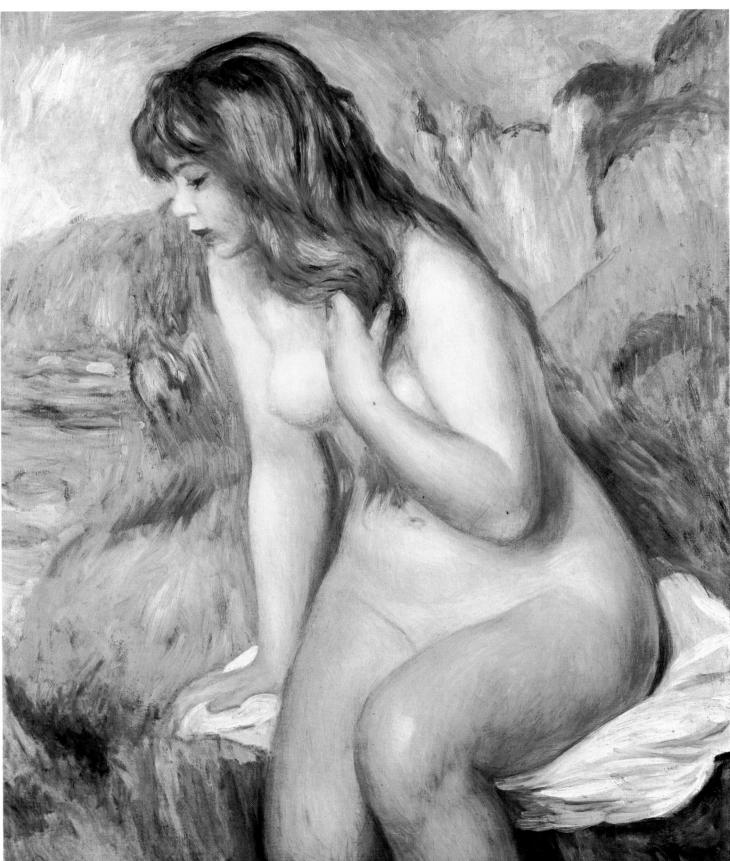

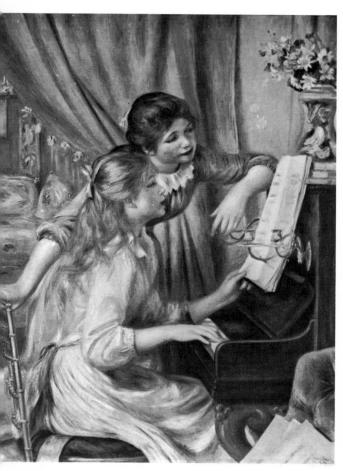

2

was able to count on purchases made by several new dealers recently interested in his work. Besides Durand-Ruel, now absorbed in setting up a business in the United States, Renoir formed connections not only with Georges Petit and with Boussod and Valadon, but also with the influential firm of Knoedler. Several active picture-brokers, such as Legrand, Portier, and Heymann, were also engaged in selling the canvases of Renoir and his friends to private collectors.

During the summer of 1888 Renoir worked at Argenteuil and Bougival and stayed for a time at Petit-Genevilliers with his friend Caillebotte.

There, on the banks of the Seine, he painted several nudes, some bathers, *The Little Girl with Sheaf of Grass and Wild-flowers*, and three slightly different ver-

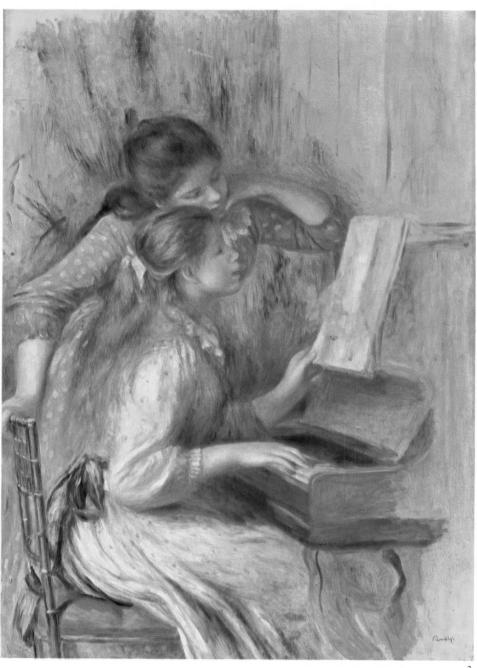

- 1 At the Piano, 1892. Pencil drawing on tracing paper, $39^3/4 \times 33^1/2$ in. Paris, Private collection.
- 2 At the Piano, 1892. Canvas, $45^3/4 \times 34^5/8$ in. Paris, Musée du Louvre. (Photo Bulloz)
- 3 At the Piano, 1892. Canvas, 44¹/₈ × 31¹/₈ in. Paris, Collection of Madame Jean Walter.
- 4 At the Piano, 1892. Canvas, $46^{1/2} \times 35$ in. Paris, Private collection.

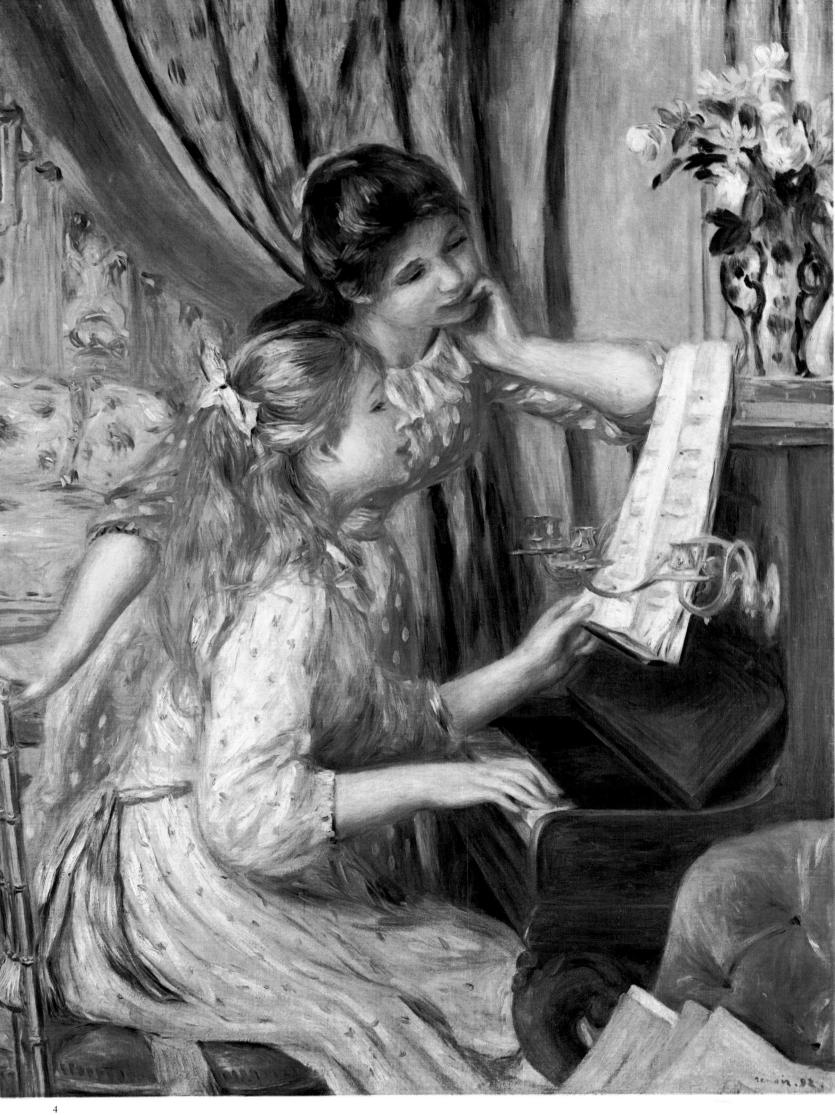

- 1 The Renoir Family, 1896. Canvas, $67 \times 54^{3}/8$ in. Merion (Pa.), The Barnes Foundation.
- 2 Renoir and the painter Louis Valtat on a bicycle, photograph.
- 3 Flowers in a Vase, 1901. Canvas, 161/2×141/8 in. Ireland, Private collection.

sions of the Girl with a Basket of Flowers. After the intense activity of these summer months, Renoir went through a period of extreme discouragement. Though to keep busy he did various informal sketches of his son Pierre and his nephew Edmond Renoir, Jr., he did not succeed in transforming these sketches into finished paintings and, moreover, destroyed many canvases. After working long and hard at La Coiffure, one of his "harsh" compositions, he failed to moderate its arid style to his satisfaction. Fortunately, while still retaining his incomparable sense of volume and fullbodied forms, Renoir broke away fairly soon from this precise and linear Ingresque manner to regain the freedom and ardor of his youth. From the beginning of his "iridescent" [nacrée] period (c. 1889), this renewal and enrichment were more and more evident in his remaining work.

After a short visit in July 1890 to Essoyes, where he painted the various versions of The Apple Vendor, Renoir returned to Paris in early August. He often enjoyed the hospitality of Berthe Morisot and her husband, who were spending the summer at Mézy, near Meulan, where they had rented the Blotière house overlooking the Seine Valley. They were old friends, and Renoir would turn up unannounced for stays of varying duration. They were always glad to see him, and there he was able to work with the added benefit of sharing Berthe Morisot's models. It was at Mézy that he painted Two Girls Picking Flowers (Museum of Fine Arts, Boston) and In the Meadow (Metropolitan Museum of Art, New York).

Henceforth Renoir devoted himself almost exclusively to nudes and portraits. He produced whole sequences of admirable canvases, with one or two figures, which are usually reinterpretations of variations of the same theme. Painted with whites and pinks, in half-tints that give the composition a pearly sheen, the *Little Girls with a Charlotte Hat*,

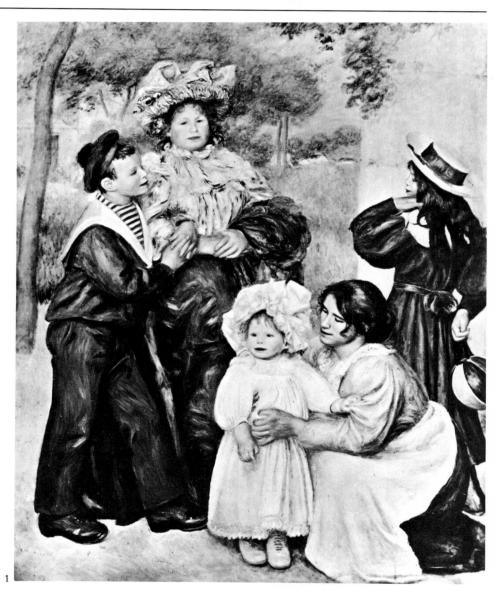

Two Sisters Reading (1890), Bather Sitting on a Rock (1892), Girls by the Seaside (1894), and especially the different versions of At the Piano (1892) all delight the eye with "their softly rounded forms gleaming with the highlights of precious stones and enveloped in golden, transparent shadows."

¹Marc Elder, L'Atelier de Renoir, Paris, 1931, vol. II, p. 34.

In 1896 Renoir brought his whole family together in a large picture painted in the garden of the "Château des Brouillards" in Montmartre, where he was then living, in pavilion No. 6. Wearing a sailor suit, Pierre hangs on his mother's arm; Gabrielle is kneeling and holding little Jean, still unsteady on his legs. On the right is the daughter of the journalist Paul Alexis, who lived next door to Renoir. This superb work, which remained in the artist's studio until his death, is now one of the glories of the Barnes Foundation in Merion, Pennsylvania. Early in his career Renoir painted some bouquets of wildflowers and, from 1896 on, often painted bunches of roses. Indeed, in his later years these flowers became almost an obsession with him. When Vollard wondered at it, Renoir replied: "They are experiments with flesh tints that I make for my nudes.

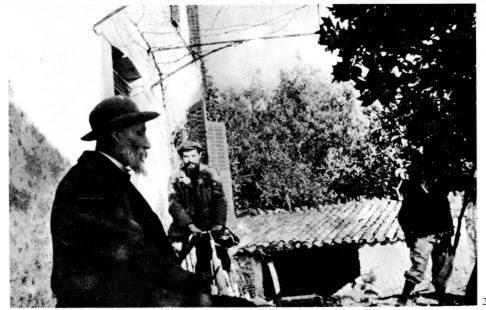

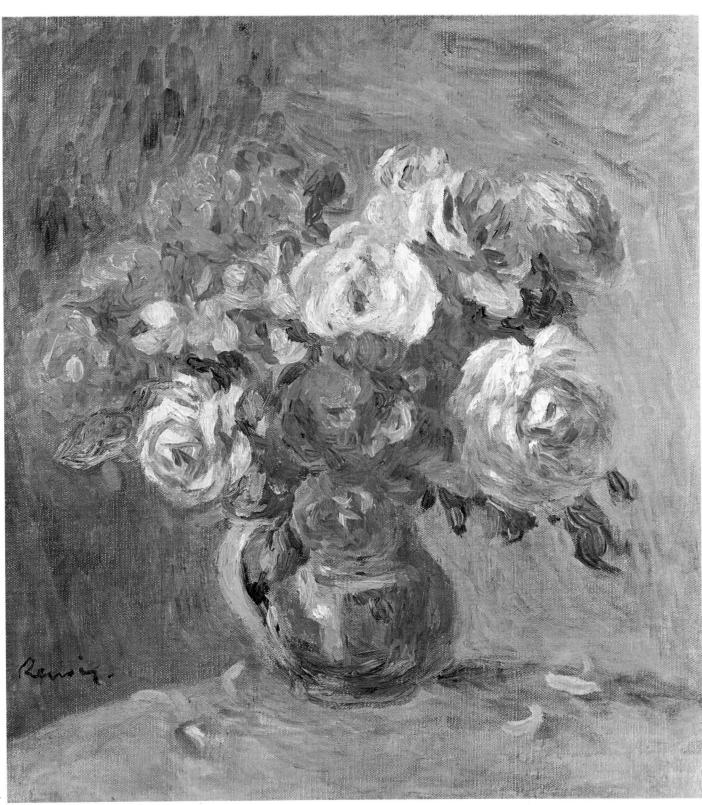

The patriarch of Les Collettes

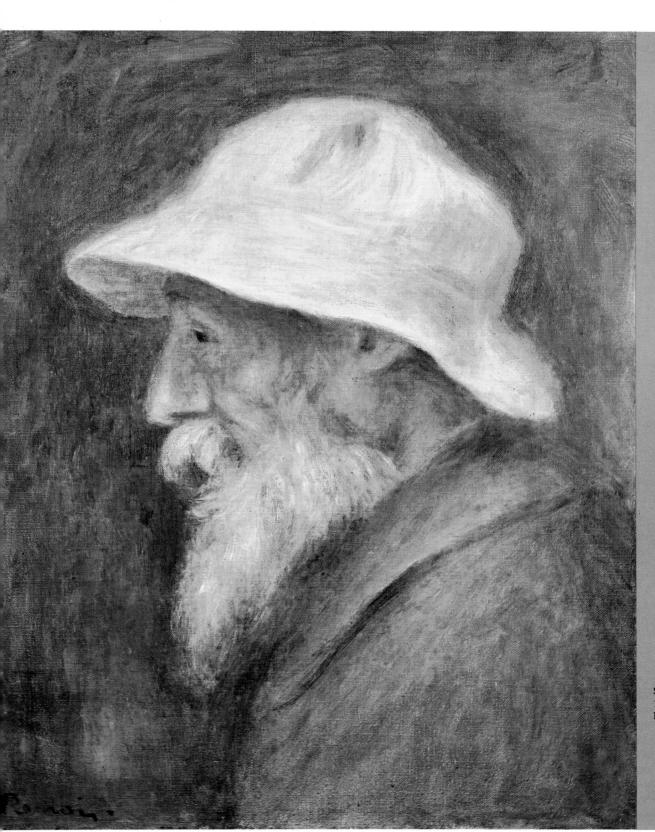

Self-Portrait with a White Hat, 1910. Canvas, $16^{1}/2 \times 13$ in. Paris, Durand-Ruel Collection.

- Renoir painting at Cagnes about 1905, photograph. (Photo Roger-Viollet)
- 2 Houses at Cagnes, 1905. Canvas, 16¹/₂ × 13 in. Paris, Private collection.
- 3 Cros-de-Cagnes, 1905. Canvas, 10¹/₄ × 11¹/₂ in. Lausanne, Private collection.

About 1900, just as he reached the height of his artistic powers and fame, Renoir was stricken with a cruel disease that gave him no respite. Rheumatism attacked his arms and legs, progressively stiffening the joints and, in the end, crippling him—yet little impairing his ability to draw and paint. Realizing he needed a milder climate than Paris, he decided to move to the south of France. He went first to the foothills behind Cannes, staying for a while at Magagnosc and Le Cannet; then, in 1903, he settled nearby at Cagnes, where for the next six years he rented a spacious apartment for himself and his family in the Maison de la Poste, the present-day town hall.

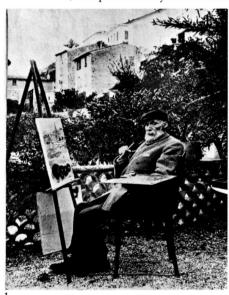

From his windows he had a fine view over all of Cagnes and the neighboring countryside. From there he painted many pictures of the houses and narrow streets of the old town, with the hills rising in tiers behind them. In most of these landscapes, especially the views of Le Cros-de-Cagnes, Renoir succeeded in conveying with perfect accuracy the unique sunlight of the Midi, the wonderful luminosity of the warm, crystalline colors of the French Riviera, set off by the ever-present blue of the sea.

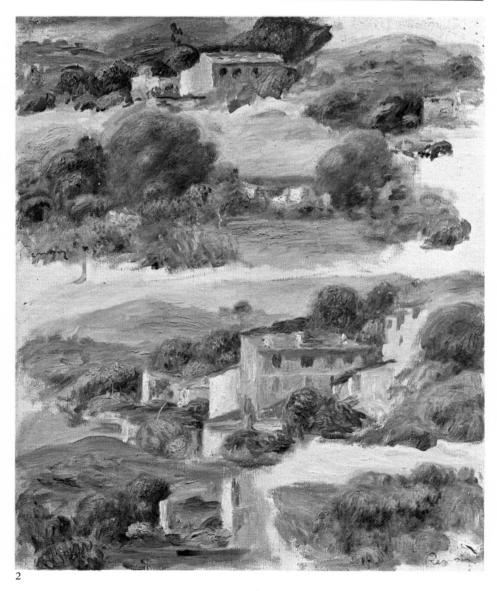

From his first arrival in Cagnes, Renoir did not limit himself to representing the landscapes and flowers around him. Now, as before, it was in his own home that he found the most gratifying themes for his painting. Like Fragonard and Tiepolo or, closer to our own day, Pierre Bonnard, Renoir belonged to that race of artists who find so much beauty in their immediate surroundings that they never cease to marvel at it and to convey on canvas the joy and pleasure it gives them. Without exaggeration, it

can be said that no other artist has ever been more responsive to the atmosphere of his home, to his personal environment and the intimacy of family life. His wife, his three sons (Pierre, Jean, and Claude, nicknamed "Coco"), and their maid Gabrielle, a peasant girl from Essoyes—these members of his household and their everyday activities were for him the ideal models and appear again and again in his paintings, sculptures, pastels, and chalk drawings. And among these favorite models, Coco

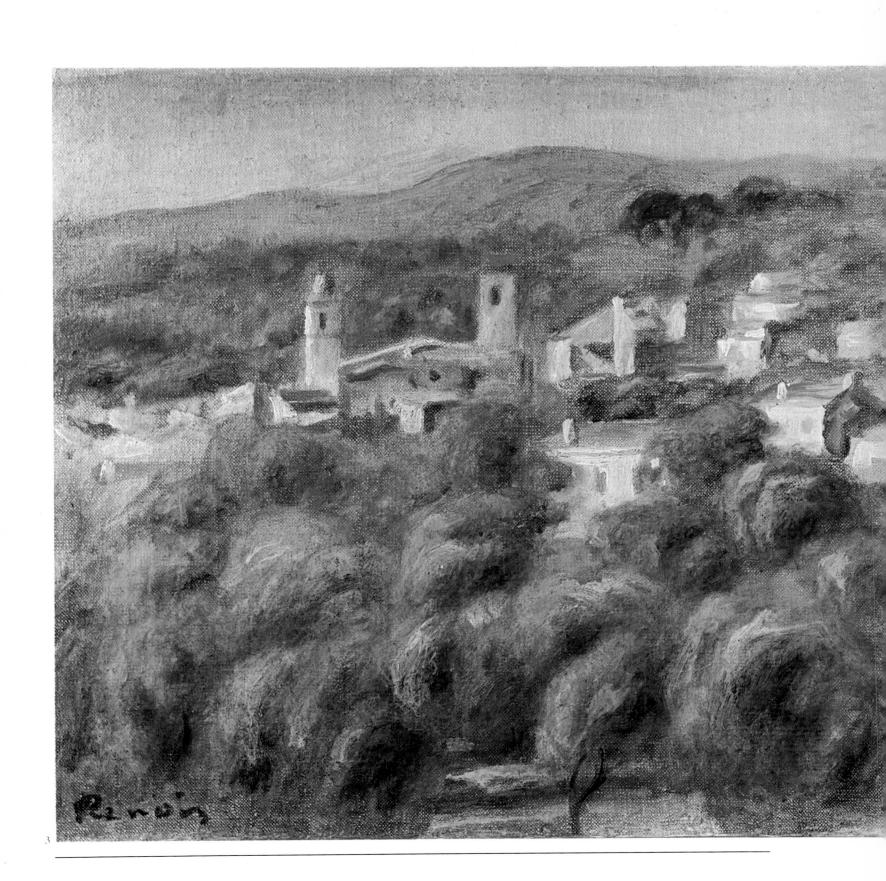

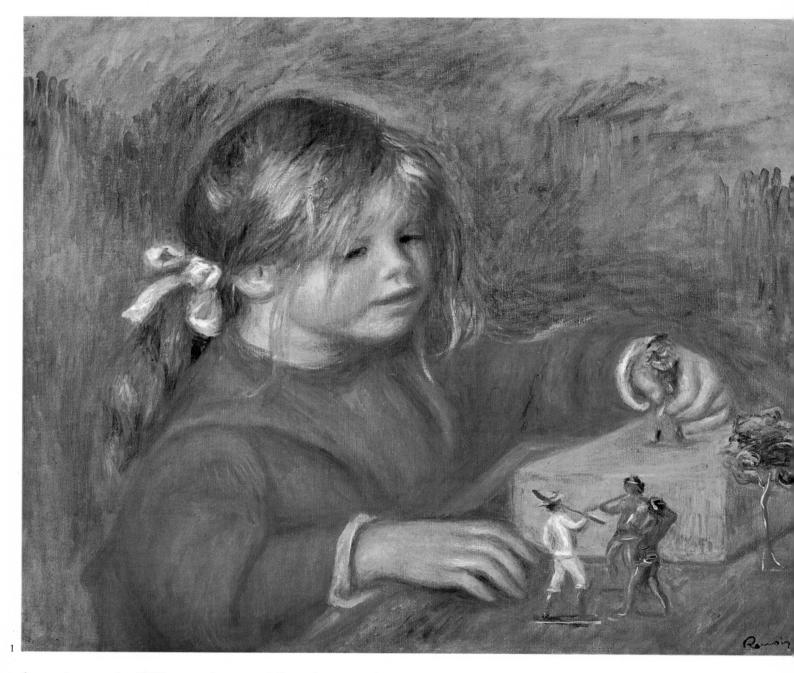

(born August 4, 1901) occupies a privileged place. Probably never before had Renoir taken so much joy in the diversions and laughter of a small child gradually discovering life. He found endless inspiration in the pink complexion, long fair hair, and plump face and figure of his youngest son. "My father," as Claude later told Michel Robida,

"allowed me great freedom. He did not want an inert model, and so I could run about as I pleased. Only now and then I had to be motionless for a few minutes. The fact is that I was mostly his badweather model. My father usually had a studio model or had a landscape he was working on. I was used instead for small sketches, such as the *Red Clown*,

unless he happened to have a definite model."1

Sometimes Renoir liked to get away from his studio and go out in an old victoria driven by Baptistin, to a place called Les Collettes, not far from Cagnes.

¹ Michel Robida, *Renoir—Enfants*, Lausanne, 1959, p. 44.

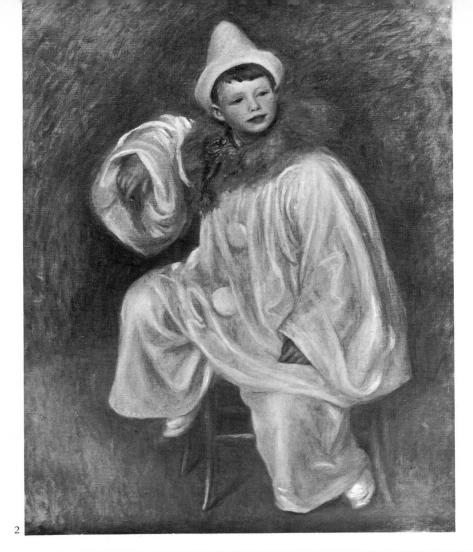

- Claude Renoir Playing with His Toys, c. 1906. Canvas, 18¹/₈ × 21⁵/₈ in.
 Paris, Collection of Madame Jean Walter.
- Jean Renoir in the Costume of Pierrot,
 1906. Canvas, 32 × 25⁵/8 in.
 Paris, Private collection.
- Still Life with Cup and Sugar Bowl, 1904. Canvas, 8¹/₄ × 12⁵/₈ in.
 Paris, Private collection.

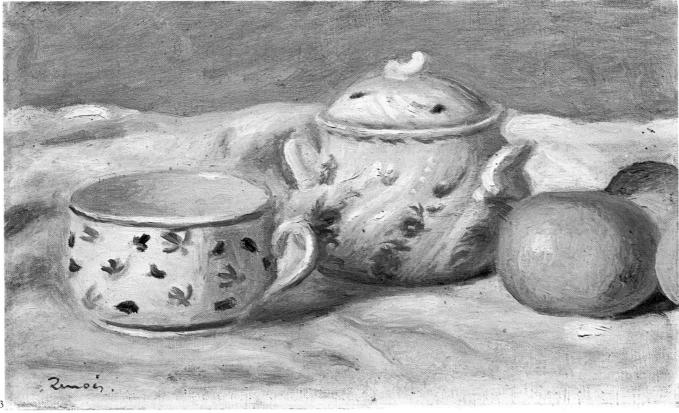

The old trees on this piece of land and the glimpses through them of Cap d'Antibes and the Estérel range never failed to entice him, and he would set up his easel in the neglected park. In his lively recollections of those days, Claude Renoir has told how their mother "took advantage of a threat hanging over the estate of Les Collettes

to extort Renoir's permission to buy it. This fine piece of property covering several hectares belonged to an old family of Cagnes. ... One day in 1907 a friend of Renoir, Ferdinand Deconchy, advised my parents of what he had heard from the notary, that a timber merchant was buying it to chop down all the olive trees. Luckily he was hag-

gling over the price, so that my mother was able to outbid him and snap it up." On June 28, 1907, Renoir thus became the owner of Les Collettes. Since, besides the olive grove, there was only an old farmhouse on the land, Re-

² Claude Renoir, "En le regardant vivre," in *Renoir*, Paris, 1970, pp. 32-33.

- 1 Renoir in his studio at Cagnes about 1913, photograph.
- Madame Renoir with Her Dog Bob,
 1910. Canvas, 32 × 25⁵/8 in.
 Hartford (Conn.), The Wadsworth
 Atheneum, The Ella Gallup Summer
 and Mary Catlin Summer Collection.

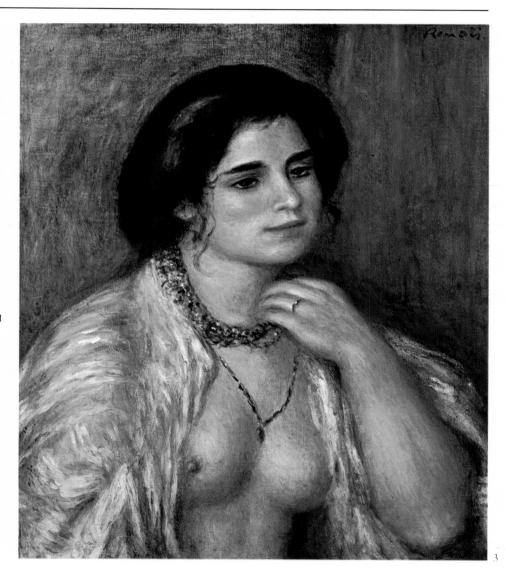

noir had a stone house built, with a parlor and dining room on the ground floor and bedrooms and a fine studio upstairs.

This move to the south, to the Midi, constitutes one of the most important events in Renoir's life as an artist. There, on the Riviera, he suddenly discovered a nature that was both ordered and luxuriant, and of which he never tired. To the very end of his life he found in his garden at Les Collettes an unfailing source of fresh inspiration. In settling for good on the shores of the Mediter-

ranean, he made another discovery: namely, Classical antiquity. Under the limpid sky of Provence, so like that of Greece, he seemed to relive the old myths of the golden age, on which the ancients had fed their imagination. "What admirable creatures those Greeks were!" exclaimed Renoir to the poet Joachim Gasquet of Aix-en-Provence. "They lived so happy a life that they imagined the gods came down to earth in order to find their paradise and true love. Yes, the earth was the paradise of the gods. ... And that is what I wish to

- Gabrielle with Bare Breasts, 1907.
 Canvas, 22 × 18¹/8 in.
 Paris, Collection of Madame Lucile Martinais-Manguin.
- 4 Gabrielle before a Mirror with Jewelry, 1910. Canvas, 31⁷/₈ × 25⁵/₈ in. Geneva, Collection of Albert Skira.

paint." So it was that, in the last years of his life, Renoir seemed intent on reawakening the lyric idylls of Anacreon and the bucolics of Theocritus, imparting to the washerwomen of Cagnes and to his maid Gabrielle the noble grace and beauty of Olympian goddesses. Among all the mythological themes that now interested him, particular mention should be made of the initial version of the Judgment of Paris (1908) and the two large oil sketches for The Rhone and the Saône (c. 1913). In a long series of red and black chalk drawings made as studies for these two subjects, Renoir recaptured with masterly ease the fullbodied forms and graceful contraposto gestures of ancient statuary.

Besides the many pictures of his children, after 1907 Renoir painted numerous portraits of the friends, disciples, critics, dealers, and collectors who came to see him at Les Collettes or his Paris apartment in Boulevard de Rochechouart. Among them were the wife and children of his physician, Dr. Prat; the dealers Paul Durand-Ruel, Ambroise Vollard, and the brothers Josse and Gaston Bernheim-Jeune; and the charming Jeanne Baudot, who has left us vivid recollectiony of Renoir. Then there were collectors such a Maurice Gangnat, a successful industrialist who had retired to the Côte d'Azur, and Frau Thurneyssen, the wife of a well-to-do

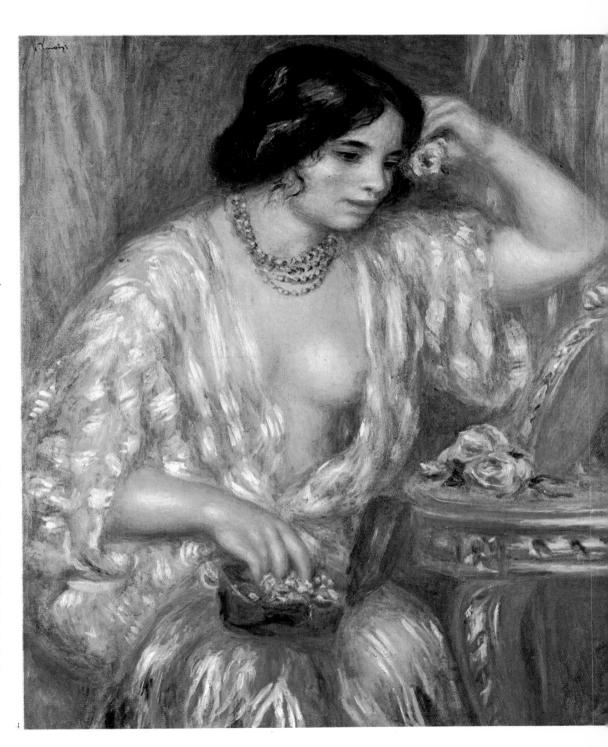

In 1907 and 1910 Renoir did some large portraits of Gabrielle, which represent the outcome of his experiments in figure painting. The daughter of a winegrower at Essoyes, Gabrielle Renard (1878-1959) was related to the

Charigots. Renoir hired her in 1894 to help his wife with the housework when she was expecting her second son, Jean. From then on, for years Gabrielle became the artist's favorite model.

¹ Joachim Gasquet, "Le Paradis de Renoir," in L'Amour de l'Art, Paris, February 1921, p. 42

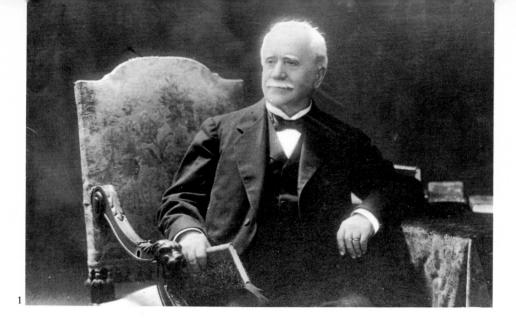

- 1 Paul Durand-Ruel in his Rue Laffitte office, Paris, about 1910, photograph.
- Portrait of Paul Durand-Ruel, 1910.
 Canvas, 31⁷/₈ × 25⁵/₈ in.
 Paris, Durand-Ruel Collection.
- Ambroise Vollard Dressed as a Toreador, c. 1917.
 Canvas, 14¹/₂ × 9⁷/₈ in.
 Paris, Musée du Petit Palais.
- 4 Washerwomen at Cagnes, 1912. Canvas, $28^{3/4} \times 36^{1/4}$ in. Paris, Private collection.

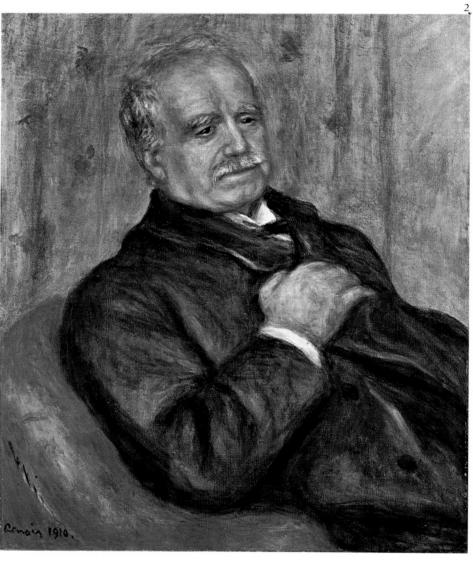

In 1910 Renoir painted the portrait of Paul Durand-Ruel (1830-1922), at the age of eighty, sitting in the office of his Rue Laffitte gallery. In this exceptional work, he recorded for posterity the sympathetic, cordial expression of the old artistic champion, whom a gossip writer of the day had dubbed "the St. Vincent de Paul of the Impressionists." The first dealer to recognize and support Renoir, Durand-Ruel through his unceasing efforts, courage, and aesthetic discernment did much to establish the painter's reputation in both Europe and America.

Munich businessman, who had become a passionate admirer of Renoir's work. But to these occasional models Renoir no doubt preferred the local girls of Le Béal, Nice, or Menton who came regularly to sit for him either in his studio or outdoors, and whose skin caught the light so well. They included Gabrielle Renard, Madeleine Bruno, Hélène Bellon, Joséphine Gastaud, and Andrée Hessling (the "Dedé" who in 1920 became Jean Renoir's first wife), and are seen in many of his pictures of bathers

and washerwomen. With their intense colors, their harmonies of red and blue, these works represent the culmination of Renoir's lifelong experiments in figure painting. In his last years, nothing seemed too rich or sumptuous, so bursting with life, to the artist to suggest the generous, supple bodies of these triumphant Venuses. The blood of life should be seen pulsing in their faces, arms and hands, even if they gave the impression of being red from too much washing or rubbing. "It is so nice to

paint a woman's hands," said Renoir, "but hands that are familiar with housework."

The outbreak of war in 1914 suddenly interrupted the serene, hardworking conduct of life at Les Collettes. Renoir's two older sons were called up and sent to the front. After weeks of anxiety, waiting day after day for news, Renoir and his wife learned that both Pierre and Jean had been seriously wounded. Aline went at once to Carcassonne, then to Gérardmer, where they were hospitaliz-

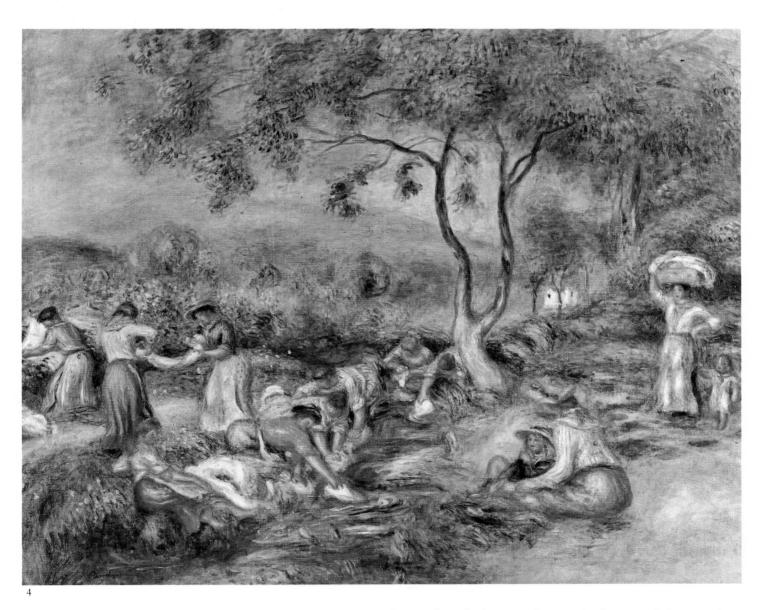

ed. From this difficult journey through wartime France, she returned home reassured concerning the welfare of her two boys, but exhausted and distressed by all that she had seen. On her arrival at Cagnes she took to her bed. Renoir had her transferred to a hospital in Nice, where everything possible was done to save her. But her health had broken down, and she died on June 28, 1915. Renoir survived her by only a few years. In August 1919, after a stay at Essoyes,

he was able to spend several weeks in Paris, where he had the pleasure of seeing his *Portrait of Madame Charpentier* exhibited in the Louvre, in the La Caza room. Received at the museum with great deference, the old master was taken from room to room in his wheelchair—"like a pope of painting"—and was able to admire at his ease Veronese's *Wedding at Cana* for the last time. This was to be his final visit to Paris. Returning to his house at Cagnes, Re-

noir went back to work but caught a chill while painting in the park of Les Collettes. On December 1, 1919, after sitting for the sculptor Marcel Gimond who was doing a bust of him, and having chatted with Ambroise Vollard and Félix Fénéon, artistic advisor of the Bernheim-Jeune Gallery, he suddenly felt feverish and weak. "He had begun a small still life of two apples," wrote Fénéon, who was with him in his last hours. "Then the death agony began.

- 1 Madeleine Bruno, or The Two Bathers, 1916. Canvas, $36^5/8 \times 28^3/8$ in. Paris, Private collection.
- 2 Renoir's easel, palette, brushes, and chair in the garden at Les Collettes. (Photo Jean Clergue)
- 3 The façade of Les Collettes, with Renoir's "Venus Victorious" in the foreground, photograph.
- 4 View of Cagnes from the garden of Les Collettes, photograph.
- 5 A corner of Renoir's studio at Les Collettes, photograph.
- 6 The farmhouse at Les Collettes, photograph.

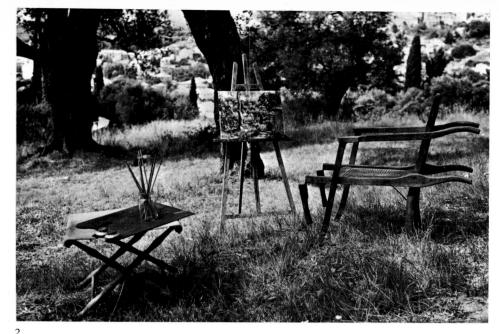

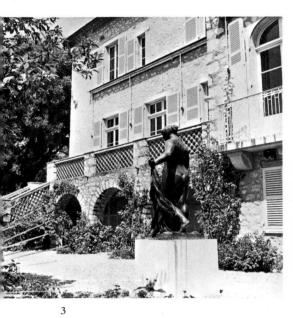

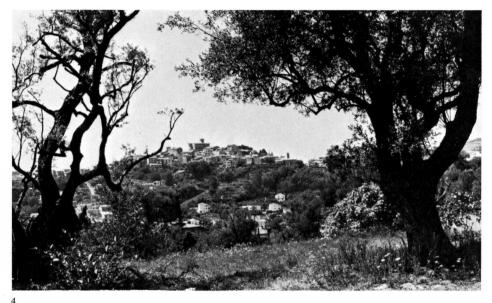

On June 28, 1907, at Cagnes on the Riviera, Renoir bought a small piece of land known as Les Collettes, on which there grew olive, medlar, and orange trees and a modest vineyard. Renoir then had a house and studio built on the property, where he spent the last years of his life—and there died in December 1919. From the time he settled at Les Collettes, he never tired of painting his garden and the fine views it afforded over the sea and the old town of Cagnes. In his studio and outdoors, he also devoted

much time to portraying his young models in the glowing beauty of their nudity. After 1908 a young girl from Le Béal, Madeleine Bruno (born 1896) frequently posed for the artist. She lived at the foot of Les Collettes, near the Old Mill where the washerwomen worked. In painting her impressive figure in the Two Bathers (1916), Renoir recaptured with effortless ease the full-bodied forms and graceful gestures of ancient Classical statuary.

Two physicians from Nice attended him, Dr. Prat, the surgeon, and Dr. Duthil. The latter was still with him at midnight, two hours before his death. Dr. Duthil had bagged two woodcocks while hunting and told his patient about this exploit. In his delirium these birds kept coming back to his mind and, associated with notions of painting, were his last concern. 'Give me my palette. ... These two woodcocks. ... Turn that woodcock's head to the left. ... Give me back my palette. ... I can't seem to paint that beak. ... Quick, some colors. ... Change the position of those woodcocks. ...' He died at 2 A.M. on Wednesday, December 3, 1919."1

¹ Félix Fénéon, "Les derniers moments de Renoir," in *Bulletin de la Vie Artistique*, Paris, December 15, 1919, p. 31.

Documentation

Renoir year by year

Venus and Cupid (Allegory). Canvas, 18¹/₈ × 15 in. Paris, Private collection.

With this lovely bather looking at her reflection in the water, there first appears what was later to become one of Renoir's favorite themes. Though this fairly conventional picture remains very much in the taste of the period, it already shows something of the painter's personal vision.

1861
Pierrot and
Columbine.
Canvas, 11 × 9 in.
Paris, Private
collection.

In his early years Renoir painted some genre scenes, for which he took his themes from Italian comedy.

1862 Sleeping Cat. Canvas, $9^{1/2} \times 13^{3/8}$ in. Paris, Private collection.

Renoir was no animal painter. On a few occasions, however, he did paint cats, whose graceful movements attracted his eye.

1863 Copy of central part of Rubens's "Hélène Fourment and Her Children" (Louvre). Canvas, 28³/4 x 23¹/4 in. Zug (Switzerland), Private collection.

From 1861 to 1863 Renoir was an assiduous visitor to the Louvre, where he made copies of the canvases he most admired, works of Rubens and of the 18th-century masters, in particular Fragonard's *Holy Family* and Boucher's *Diana*.

1864
Portrait of Mlle Romaine Lacaux. Canvas, 31⁷/8 × 25⁵/8 in. Cleveland, The Cleveland Museum of Art, Gift of Hanna Fund.

Of all the Impressionist painters, Renoir was perhaps the only one except for Berthe Morisot who succeeded in capturing so well the artlessness, spontaneity, and the purity of little girls. He was much taken with their natural tendency to foolery, mixed with shyness.

Portrait of Mlle Sicot. Canvas, 48³/4 × 38¹/4 in. Washington, D.C., The National Gallery of Art, Chester Dale Collection.

In this large composition, which recalls Courbet, Renoir has done a searching portrait of a young Parisian actress.

1866 Holiday at Saint-Cloud. Canvas, 19³/4 × 24 in. Viroflay, Private collection.

1867
Lise with a
Bouquet of Wildflowers. Canvas,
25¹/2 × 19³/4 in.
Paris, Private
collection.

In July and August 1867, Renoir stayed at Chailly-en-Bière and Chantilly with his mistress Lise Tréhot. In two similar pictures, painted entirely outdoors, he portrayed Lise holding a bouquet of flowers, standing at the edge of the wood.

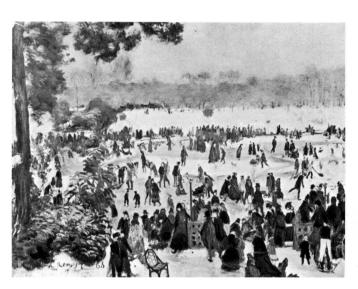

1868 – Ice Skaters at Longchamp. Canvas, $28^3/8 \times 35^1/2$ in. Basel, Private collection.

Renoir did not care for snow, which he once called "that leprosy of nature." Nonetheless he painted two or three winter landscapes, which effectively convey the mood and aspect of the dormant country-side. In this work the tiny figures gliding over the ice in all directions serve less to animate the scene than to set up some sort of human benchmarks to indicate the proportions of nature.

1869 Woman with a Bodice of Chantilly Lace. Canvas, $31^7/8 \times 25^5/8$ in. Geneva, Collection of Max Moos.

This portrait of Rapha, the mistress of Edmond Maître, shows the influence of both Velázquez and Manet. In the background is a cabinet that Renoir had decorated for his Bordeaux friend.

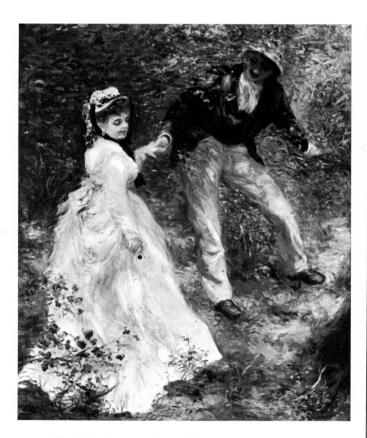

As early as 1866 Renoir had become a firm convert to using a bright palette and working directly from nature. But it is perhaps here in *The Walk* that we first see most clearly what was to become the artist's chief concern after the Franco-Prussian War: the merging of timeless poetic elements with an accurate image of contemporary life.

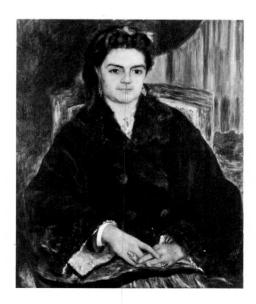

1871 Portrait of Mme Darras. Canvas, 31⁷/8 × 25⁵/8 in. New York, The Metropolitan Museum of Art.

In the autumn of 1871, through Jules Le Coeur, Renoir met Captain Paul Darras along with his young wife, who commissioned portraits from him. He liked the couple and was delighted to accept the commission. He began with this portrait of Mme Darras.

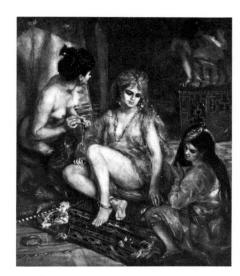

or The Harem.
Canvas,
61³/4 × 51¹/4 in.
Tokyo, National
Museum of
Western Art.

Renoir had abiding admiration for Delacroix, so reminiscences of his Women of Algiers are found in several of Renoir's pictures: for example, The Harem, submitted unsuccessfully to the Salon of 1872. This large painting is the last in which one sees the lovely face of Lise Tréhot.

Parisian Women Dressed as Algerians,

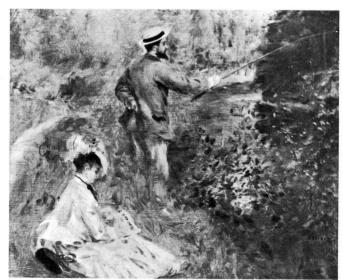

1875 The Great Boulevards, Paris. Canvas, $19^{3/4} \times 24$ in. New York, Private collection.

Like Manet and Monet, Renoir painted several views of Paris in 1875. With its decidedly modern spatial thrust and perspective, and above all the bright shimmering color applied with brushstrokes laid on separately, one beside the other, this animated view of a Parisian boulevard is characteristic of the new approach of the Impressionists.

1876 Roses in a Vase. Canvas, $24 \times 19^{3/4}$ in. New York, Collection of Mr. and Mrs. Harry W. Anderson.

1877 Portrait of Jeanne Samary, or Reverie. Canvas, 22 × 18 in. Moscow, Pushkin Museum.

Jeanne Samary, a young actress at the Comédie Française, posed several times for Renoir from 1877 to 1880. He never failed to be charmed by her imagination and beauty, her winning smile and gaiety.

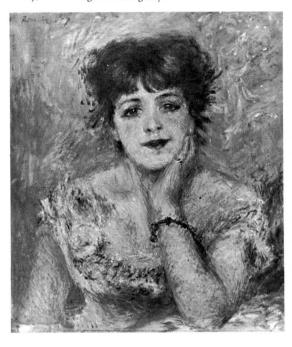

1878 The Cup of Chocolate. Canvas, 39³/8 × 317/8 in. Grosse Pointe Shores (Mich.), Collection of Mrs. Edsel B. Ford. (Photo Bulloz)

The model for this picture, painted in Renoir's studio in Rue St-Georges, was a young woman of Montmartre, Marguerite Legrand ("Margot").

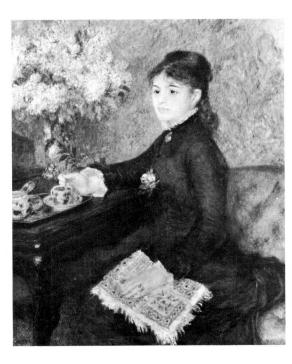

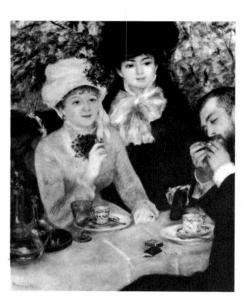

1879 The End of a Meal. Canvas, 39³/8×31⁷/8 in. Frankfurt, Städelsches Kunstinstitut.

Kunstinstitut.

This painting was inspired by the garden of the Cabaret d'Olivier in Montmartre. The woman holding a glass is the actress Ellen Andrée. The woman standing behind her has yet to be identified, but she was one of Renoir's favorite models at this time. The man lighting a cigarette is the artist's youngest brother, Edmond.

1880 Sleeping Girl with a Cat. Canvas, 47¹/4 × 35¹/2 in. Williamstown (Mass.), The Sterling and Francine Clark Institute.

Institute.

In this sleeping girl, half-undressed, with a cat on her lap, one recognizes the features of Angèle, a pretty young florist of Montmartre. "Impudent and naïve," she was one of Renoir's favorite models from 1878-1881.

1881 Arab on a Camel. Canvas, 28³/4 × 30 in. New York, Private collection.

1882 The Daughters of Paul Durand-Ruel. Canvas, 31⁷/₈ × 25⁵/₈ in. Norfolk (Va.), Chrysler Museum, Gift of Walter P. Chrysler, Jr.

In August 1882 Renoir painted a portrait of the daughters of his dealer, Marie-Thérèse and Jeanne Durand-Ruel. Here he emphasized the play of natural light on the girls' faces, in this way harmonizing the figures with the surrounding foliage.

1883 Seated Bather Drying Her Left Foot. Canvas, $25^{1/2} \times 21^{5/8}$ in. Paris, Collection of Mme. Jean Walter.

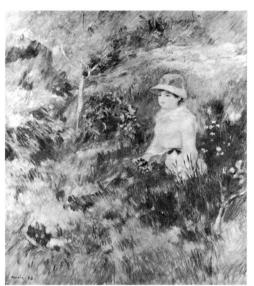

1884 Summer, or Mme. Renoir in a Flowery Field. Canvas, 31⁷/8×25⁵/8 in. New York, Ittleson Coll.

This fine picture of Renoir's future wife, Aline Charigot, sitting in a flowery meadow, was painted at Chatou.

1885 At Water's Edge. Canvas, 21¹/2×25³/4 in. Philadelphia, Museum of Art, Given by Frank & Alice Osborn.

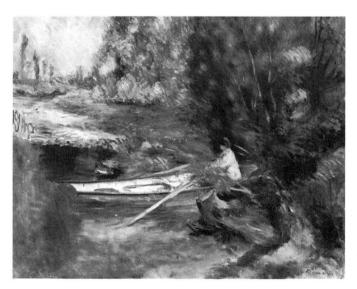

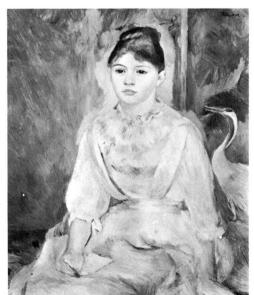

1886
Girl with a Swan.
Canvas,
30×24¹/2 in.
New York, Mr.
& Mrs. Dunbar
W. Bostwick.

W. Bostwick.

This charming model, with her almond-shaped eyes and her strongly drawn eyebrows, her slightly upturned nose and full ruby lips, typifies the sort of female beauty Renoir was especially fond of.

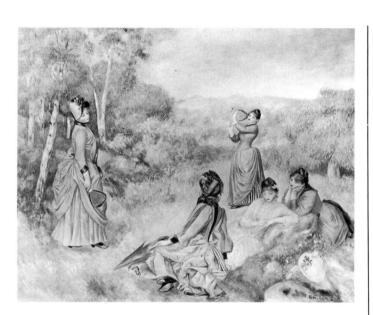

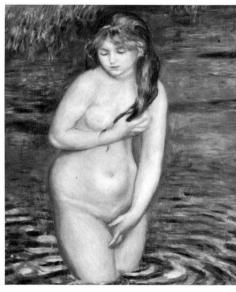

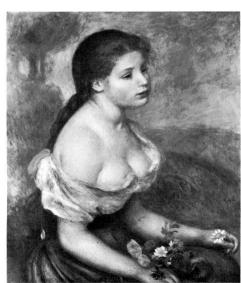

1887 Girls Playing at Shuttlecock. Canvas, 21¹/4 × 25⁵/8 in. New York, Mrs. Huguette Clark.

Despite a certain coldness and a decided mannerism in the tilt of the girls' heads and their rather affected poses, this painting is an outstanding example of Renoir's "harsh" period.

1888 Young Woman Bathing. Canvas, 31⁷/8 × 25⁵/8 in. Washington, D.C., Mr.&Mrs. David Lloyd Kreeger.

1889
Girl with Daisies.
Canvas,
25⁵/8 × 21¹/4 in.
New York, The
Metropolitan
Museum of Art,
Mr. & Mrs.
Henry Ittleson,
Jr., Purchase
Fund.

In this dark-eyed girl who wears a very décolleté dress, Renoir has captured an unforgettable image of young womanhood.

1890 The Two Sisters, or Girls Drawing. Canvas, $18^{1/8} \times 21^{5/8}$ in. Paris, Collection of Stavros S. Niarchos.

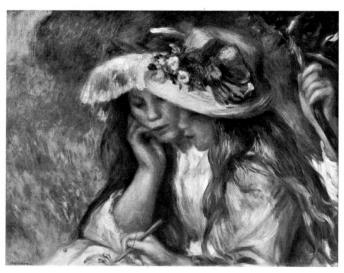

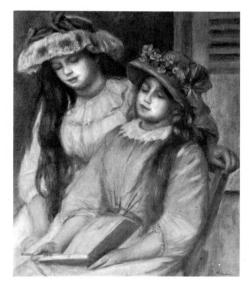

1891 Girls Looking at an Album. Canvas, 31⁷/8 × 25⁵/8 in. Richmond, The Virginia Museum of Fine Arts. (Photo Knoedler, N.Y.)

Reading is a recurring theme in Renoir's work. In catching his young models in such quiet moments, as they read or leaf through the pages of a book or picture album, he was able to represent them in a thoughtful and harmonious, and perfectly natural pose.

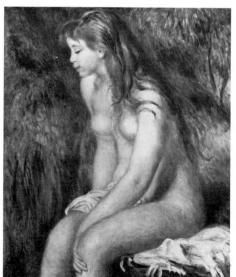

Nude Girl, or The Young Bather. Canvas, 31⁷/8 × 25⁵/8 in. New York, Private collection.

In this nude whose supple contours merge fluidly into the background pattern of the foliage, we see "a type of young woman so appealingly fresh and shapely... with a grace that is half-child, half-animal" (Paul Jamot).

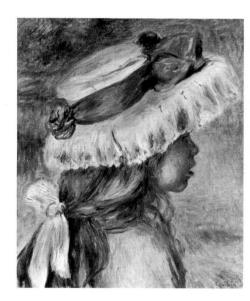

1893 Head of Little Girl with a Charlotte Hat. Canvas, $16^{1/8} \times 12^{5/8}$ in. Paris, Private collection.

In the early 1890s Renoir completed several pictures of girls wearing "charlotte" hats. These were not commissioned portraits, for Renoir preferred to choose models who suited him in order to observe their expression in very frequent sittings. Hence the charming natural ease and grace of these young faces seen in profile.

1894 Girls by the Sea. Canvas, $21^{5/8} \times 18^{1/8}$ in. Paris, Private collection.

While spending the summer of 1894 at Beaulieu-sur-Mer, Renoir painted several pictures of young women in summer frocks sitting or lying down outdoors, in view of the sea. A companion piece to the work reproduced here, in the Chollet Collection, Fribourg (Switzerland), has slight modifications: the composition is reversed, and the two girls in the foreground are not wearing hats.

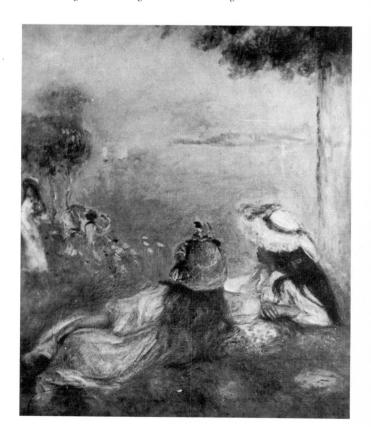

1895 Gabrielle with Jean Renoir. Canvas, 25⁵/8 × 21¹/4 in. San Francisco, Private coll.

One after another, Renoir's three sons Pierre, Jean, and Claude served as models for their artist father during their childhood. Their fresh complexions, chubby figures, and graceful natural gestures charmed both the father and the artist in Renoir.

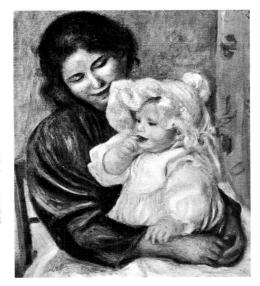

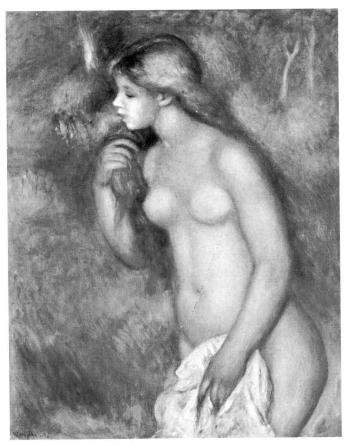

1896 Standing Bather. Canvas, $31^{7/8} \times 23^{5/8}$ in. Switzerland, Private collection.

The female nude was always one of Renoir's preferred themes. In its elegant lines, this nude is still close to the works of his "Ingresque" period.

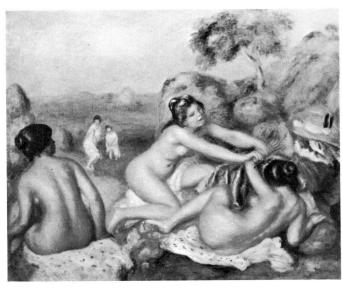

1897 Three Bathers with a Crab. Canvas, 21¹/₂ × 25⁷/₈ in. Cleveland, The Cleveland Museum of Art, Hanna Fund Purchase.

1898 Breakfast at Berneval. Canvas, 31⁷/8 × 25⁷/8 in. London, Private coll.

Renoir painted his two older sons with their nursemaid in the dining room of a chalet in Normandy he rented for the summer of 1898. In the foreground is Pierre, engrossed in a book; behind, Gabrielle is seen preparing little Jean's breakfast.

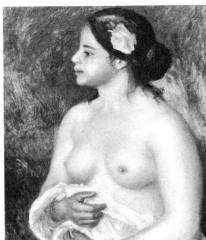

1899
Gabrielle with a Rose ("The Sicilian Woman"). Canvas, 25⁵/8 × 21¹/4 in. Paris, Private collection.

In this admirable portrait of Gabrielle, who was twentyone at the time, Renoir succeeded in conveying the radiant allure of a woman's body in all its beauty.

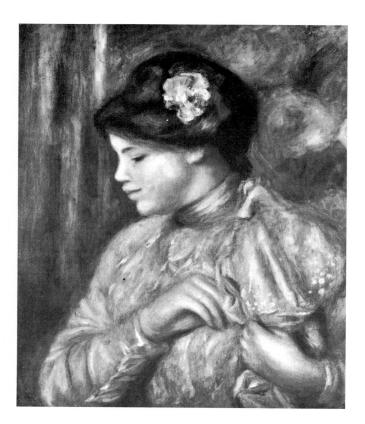

1900 Woman Arranging Her Blouse. Canvas, $21^5/8 \times 18^1/8$ in. Paris, Private collection.

1902 Reclining Bather ("La Boulangère"). Canvas, $21^{1/4} \times 25^{5/8}$ in. Paris, Collection of Stavros S. Niarchos.

In the early 1900s Renoir took endless pleasure in painting glowing young bathers, often in compositions redolent of Giorgione and Titian. Reclining, standing, sitting, washing or drying themselves, tending some slight wound or simply caught basking in the sun, they have no other concern but to expose their voluptuous bodies to the light.

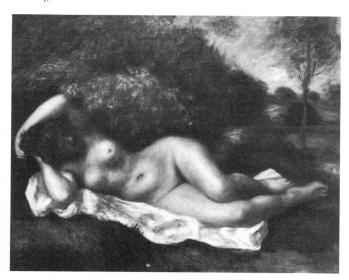

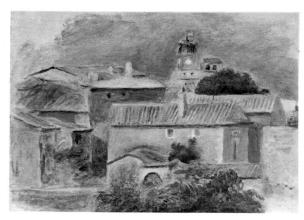

1904 View of Laudun. Canvas, 11×15 in. Paris, Private collection.

Renoir made several trips to the small town of Laudun (Gard), located on the right bank of the Rhone in Languedoc, where he stayed with his friend and pupil the painter Albert André.

1906 Maison de la Poste at Cagnes. Canvas, $12^{5/8} \times 18^{1/8}$ in. Paris, Private collection.

From the spring of 1903 to the autumn of 1908, Renoir lived mostly in the Maison de la Poste at Cagnes, on the Riviera.

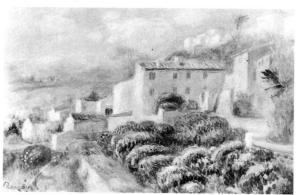

1908 The Judgment of Paris. Canvas, 31⁷/8×39³/4 in. New York, Mrs. Louise R. Smith. (Photo Knoedler, New York)

The shepherd Paris, with a Phrygian cap on his head, awards the golden apple to Aphrodite. Aside the triumphant beauty are her disappointed rivals Hera and Athena, who express surprise and regret.

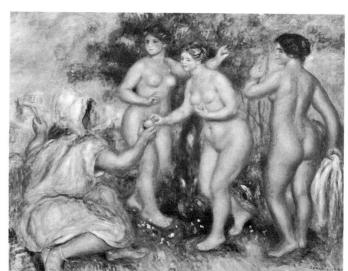

1910 Roses in a Vase. Canvas, $17^{3/8} \times 18^{1/8}$ in. Geneva, Private collection.

At Les Collettes, Renoir painted this bouquet of full-blown roses, with all the glow and freshness of their flesh tones. The floral-patterned vase containing them appears in several compositions of this period.

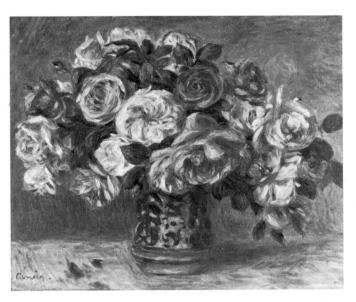

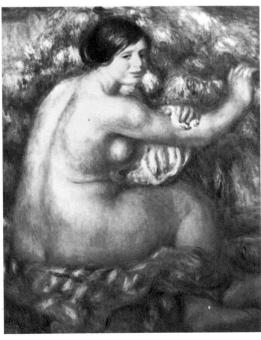

Whether she represents Venus or the baker's daughter, Gabrielle or Dédé, the ideal woman painted by Renoir has a long torso, broad hips, proportionately short legs, and rounded fleshy arms.

1914 The Farmhouse, Les Collettes. Canvas, $21^{1/4} \times 25^{5/8}$ in. New York, Private collection.

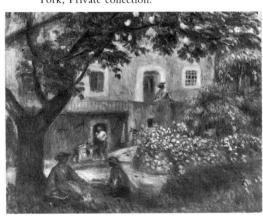

To paint this view of his garden at Les Collettes, Renoir used a color scale of emeralds and rubies, boldly laying on tightly packed, yet transparent touches of carmine against thick shadows of foliage" (François Fosca).

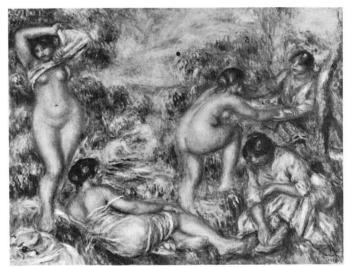

1916 Group of Bathers. Canvas, 28³/₄ × 36¹/₄ in. Merion (Pa.), Copyright 1972 by The Barnes Foundation.

With their supple, full-bodied forms, these gorgeous bathers may be considered a freer, more high-keyed version of the *Large Bathers* in the Philadelphia Museum of Art.

1918 – The Large Bathers, Canvas, $43^{1/4} \times 63$ in, Paris, Musée du Louvre.

For this wide canvas, justly described as his artistic testament, Renoir took as his model Andrée Hessling ("Dédé"), who later became the wife of his son Jean.

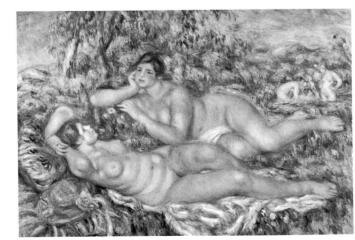

Expertise

Unlike so many little masters of the nineteenth century who treated new themes but in a traditional manner, without any decisive effect on their way of seeing, Renoir was a modern both in outlook and technique. With him, the renewal of subject matter was accompanied by a renewal of the means of expression. Very early, by working hard at it, he created a personal palette—the so-called "rainbow" palette—and handled it with new and appropriate accents all his own. This is why, at first glance, even before reading the signature, one recognizes a Renoir by its very distinctive style and handling. It should be clear, then, that neither a study of the historical circumstances surrounding its creation nor an apparently flawless pedigree suffices to authenticate a work by Renoir. Before all else, that work—whether an oil painting, pastel, watercolor, or drawing—must be studied carefully on its own.

Renoir almost invariably painted on stretchers of a standard make, supplied by one of his earliest supporters, Monsieur Legrand. He preferred to work on a very fine-grained canvas. Before beginning his picture, he often covered his canvas with a white primer coat, which gave a lighter hue to the scumblings. After the experiments and hesitations of his early period-more precisely, from the time of The Loge (1874) and, above all, after The Luncheon of the Boating Party (finished 1881)—Renoir fixed on a choice of colors that was to remain more or less definitive for him. According to Monsieur Edouard and Monsieur Moisse, who were his regular suppliers of pigments, Renoir kept to this choice until his death. Now and then, no doubt, his palette underwent certain changes; he would drop emerald green or add a new indigo blue. But on the whole he kept to the following colors: silver white, chrome yellow, Naples yellow, yellow ocher, burnt sienna, vermilion, madder-red lake, Veronese green, emerald green, cobalt blue, ultramarine blue (cf. the list of colors illustrated on page 51). Very particular about the quality of the colors he used, Renoir was equally so in choosing his brushes. He preferred brushes of gray marten fur made in Russia, known as Melloncillo brushes. To dilute the pure pigments, he used a mixture of linseed oil and rectified turpentine. The proportion of oil was one of his constant preoccupations, for he was anxious to make his pictures as durable and time-resistant as possible. "Painting is not a matter of daydreaming," he told his pupil Albert André. "It is first

The Two Sisters, or Two Girls, c. 1890. Canvas, $18^{1/8} \times 21^{5/8}$ in. Paris, Collection of Madame lean Walter.

Girl with a Straw Hat (Mademoiselle Alphonsine Fournaise), 1880. Canvas, $19^{3/4} \times 24$ in. Lausanne, Private collection.

of all a handicraft and calls for good workmanship." Apart from a few sketches, which he no doubt considered unfinished works, Renoir signed all the canvases he sold or gave away. Until about 1875, in the signature, his surname was preceded by the initial of his Christian name, written thus in separate letters: "A. Renoir." Sometimes, on small-sized pictures, he contented himself with signing his initials: "A.R." Later he got into the habit of signing his paintings with his surname alone: "Renoir." He wrote it with more or less thick strokes and, according to the period, sometimes in black,

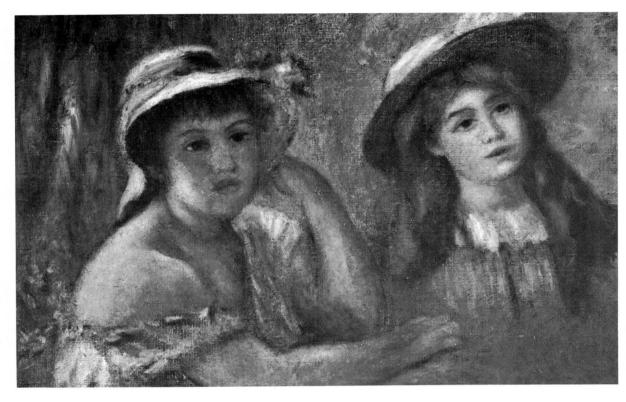

The Two Sisters? Fake skillfully devised of elements taken from two pictures by Renoir (Figs. 1 and 2).

sometimes in white or red. During the first half of his career, he generally dated his pictures; after 1885 he very rarely did so. For this reason, it is often difficult to assign a precise date to the works of his maturity and old age. At the time of Renoir's death, the majority of the canvases in his Cagnes and Paris studios—many of them unfinished—were unsigned. Accordingly, his heirs had an identifying signature stamp placed on each of these to authenticate them and establish their provenance.

In spite of the difficulties involved in copying the inimitable style and handling of the painter of *Le Moulin de la Galette* and the *Large Bathers*, a number of more or less skillful fakes began to appear after Renoir's death, and some even during his lifetime. At present, unfortunately, quite a substantial number of fake Renoirs are known to exist. For the most part, these are easily recognizable and can be divided into three groups.

The first group, by far the largest, consists of anonymous works to which an apocryphal signature imitating that of Renoir has been added. These are figure paintings, landscapes, or still lifes by minor artists of the late nineteenth century whose style, execution, and general aspect have a marked resemblance to the manner of Renoir. As early as 1920, a scandal occurred in New York when it was discovered that thirty-three canvases and ninety-six pastels and drawings, already sold as Renoirs at an auction at the Anderson Gallery, were actually the work of a painter named Lucien Mignon. Skillful forgers had effaced the signatures of this unknown artist and replaced them with the faked signature of Renoir.

The second group consists essentially of copies made after famous paintings by Renoir. Usually executed in front of the original or from color reproductions of it, this type of copy is generally restricted to works readily accessible in public museums or collections. The Torsó of Anna, The Swing, The Luncheon of the Boating Party, and the Girls at the Piano have often been the object of gross forgeries, which unscrupulous dealers have presented as preparatory studies or variants by the master himself. Though in most cases such copies are easily identifiable, when they imitate Renoir's later works it is sometimes much more difficult to tell the copy from the original. In the end, however, none of these fakes can stand up to careful, expert examination. Renoir can always be distinguished from his many imitators. Ultraviolet rays enable us to detect overpainting and check the authenticity of a signature. Chemical samples may also provide valuable clues, for contemporary copyists are likely to use synthetic colors that were unknown in Renoir's day.

Finally, there is a third group of works which cannot be confused with authentic canvases by Renoir. These are outright fakes, wholly made up by forgers hoping to profit from their plagiaries. Sometimes inspiration is taken from several works by Renoir belonging to different periods of his career, and the various elements are skillfully pieced together to make up what appears to be an original work. Thus, in the fake reproduced above, the forger has plagiarized two portraits, both popularized by reproductions: the *Girl with a Straw Hat (Mademoiselle Fournaise)*, dating from 1880, and the *Two Sisters*, of about 1890 (formerly in Paul Guillaume Collection).

Renoir and the Bérard family

The parents

Among the keen and enlightened collectors who first discovered and defended Renoir's work, Paul Bérard and his wife deserve special mention. Beginning as a diplomat, afterward a banker and company director, Paul Bérard (1833-1905) early in his career married Marguerite Girod (1844-1901), with whom he had four children. In 1879 this intelligent, and cultivated upper-middle-class Protestant couple met Renoir through Charles Deudon, who three years previously had purchased The Dancer, one of the acknowledged masterpieces of the artist's early period. Renoir and the Bérards developed a warm sympathy for one another at once. From that time on, until Paul Bérard's death in 1905, Renoir was a frequent guest at his patron's Parisian townhouse, at 20 Rue Pigalle. It was there he portrayed his friend in a casual pose, relaxing in an easychair and smoking a cigarette, and also his young wife, whose sweet and gentle nature can be read in her eyes and face. Comparing these portraits with snapshots of the same period, one can see what a close and searching likeness their painter has given of his models. Renoir was often invited in the summer to the Bérards' country house at Wargemont, near Dieppe. As a nephew of the Bérards later wrote of Renoir, "He found in that gracious home a frank and simple hospitality which, within the luxuriant setting provided by nature, created around him a free and easygoing atmosphere highly favorable to the blossoming of his genius."

- Portrait of Paul Bérard, 1880. Canvas, 19³/₄ × 15³/₄ in. Paris, Madame Edouard Renaudeau d'Arc.
- 2 Paul Bérard about 1880, photograph.

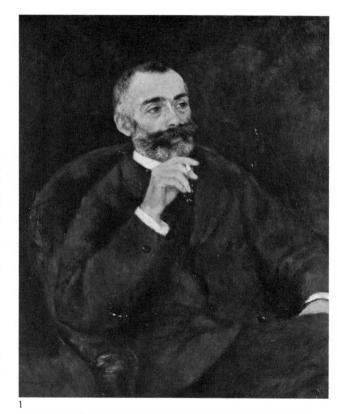

- 3 Portrait of Madame Paul Bérard, 1879. Canvas, 31¹/2×25⁵/8 in. Paris, Madame Edouard Renaudeau d'Arc.
- 4 Madame Paul Bérard (born Marguerite Girod), in 1879, photograph.

- Marthe Bérard, or Little Girl with a Blue Sash, 1879. Canvas, 51¹/4×29¹/2 in. São Paulo, Museu de Arte. (Photo Bulloz)
- 6 Marthe Bérard in 1879, photograph.

The children

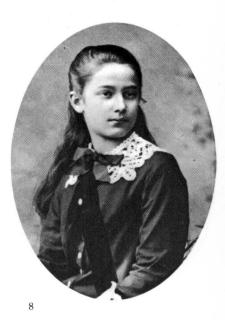

In March 1879 Paul Bérard commissioned an initial portrait from Renoir, that of his eldest daughter Marthe (later Madame Roger de Gallye d'Hybouville), who was then nine years old. In painting it, wrote Théodore Duret, Renoir "cautiously kept to a scale of sober tones in order not to startle his patron. He abstained from bright colors. ... The portrait pleased the girl's parents and friends of the family who

came to see it." From then on, the artist was on intimate terms with the Bérard family. While staying at Wargemont with them that summer, he painted several pictures of their son André (born 1868), in his blue school uniform with a large white collar, and also their niece Thérèse Bérard, wearing a lace-trimmed mauve-colored bodice.

- 9 André Bérard in his school uniform in 1879, photo.
- The Little Schoolboy (André Bérard), 1879. Canvas,
 15³/₄ × 12⁵/₈ in. New York,
 Mr. and Mrs. Josef Rosensaft.
- 11 Portrait of André Bérard, 1879. Canvas, 15³/₄ × 12⁵/₈ in. Paris, Madame Edouard Renaudeau d'Arc.

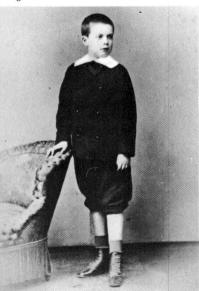

- Portrait of Thérèse Bérard, 1879.
 Canvas, 22 × 18¹/2 in.
 Williamstown (Mass.), The Sterling and Francine Clark Institute.
- 8 Thérèse Bérard in 1879, photograph.

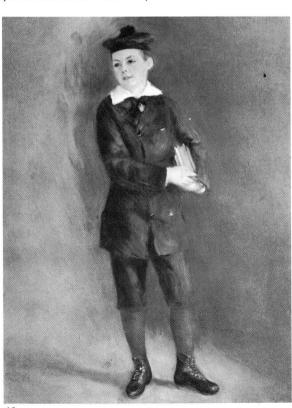

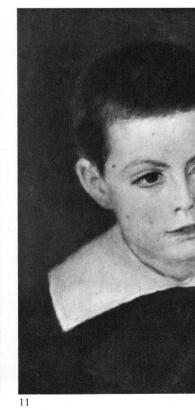

Wargemont and its Beach

The Bérard summer home, the Château de Wargemont on the road to Tréport, was surrounded by a large park and stood near the sea. Renoir took advantage of his first stay there, in the summer of 1879, to work out a large figure composition intended for the 1880 Salon; this depicts four young girls fishing for mussels on the neighboring beach of Berneval. In the girl with dishevelled hair we recognize the model for the Gypsy Girl in the Meyer Collection. During the same summer, he also painted a portrait of Marthe Bérard by the sea, dressed in a fishing outfit. Wearing a white-striped blouse and knickers and a straw hat trimmed with ribbons, the little girl is out to catch shrimp with a net (Fig. 15). A few months later, Renoir agreed to paint in secret a replica of this charming picture for Madame de la Perrière, Marthe's godmother (Fig. 14).

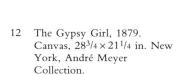

- 13 Girls Fishing for Mussels at Berneval, 1879. Canvas, 69×51¹/4 in. Merion (Pa.), Copyright 1972 by The Barnes Foundation.
- 14 The Little Fisherwoman (Marthe Bérard), second version, 1879. Canvas, 24×18^{1/8} in. New York, Mr. and Mrs. Josef Rosensaft.
- 15 The Little Fisherwoman (Marthe Bérard), first version, 1879. Canvas, 23⁵/₈ × 17³/₄ in. Geneva, Private collection.

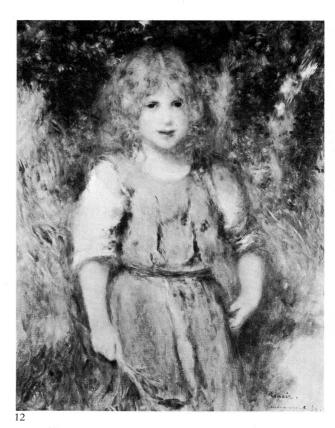

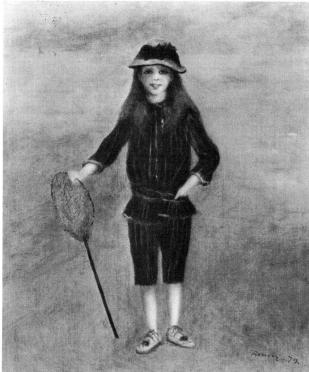

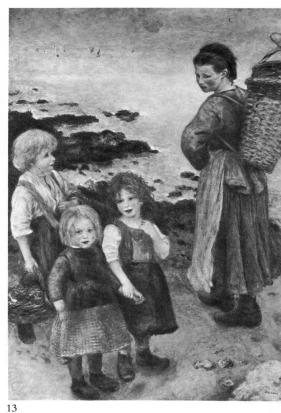

The Wargemont decorations

During the summer of 1879, Renoir not only painted portraits of the Bérard children and beach scenes but also did a large allegorical composition to de-

corate the drawing room of the Château de Wargemont. At the request of his hosts, he took as his theme *The Festival of Pan*. Around the god's bust, crowned with white roses, young people weave garlands to celebrate the return of spring. Two years later, in August 1881, Renoir painted several still lifes to decorate the dining room of his friends' Normandy manor. Two of these are particularly fine: one representing velvety peaches in a Delft bowl, the other of a dead pheasant lying in the snow.

- 16 The Festival of Pan, 1879. Canvas, 23⁵/8 × 28³/8 in. New York, Private collection.
- 17 Pheasant on the Snow, 1879. Canvas, 19¹/4×25¹/4 in. Geneva, Collection of L.C. Stein.
- 18 Still Life with Peaches and Grapes, 1881. Canvas, 21¹/4×25⁵/8 in. New York, The Metropolitan Museum of Art, Mr. and Mrs. Henry Ittleson, Jr., Purchase Fund.

18

The flowers of Wargemont

At Wargemont Renoir indulged again in the pleasures of open-air painting which he had so enjoyed at Argenteuil and Chatou. In a canvas vibrant with light he represented the Bérards' manor house, with its weathered brick façade seen above the rose garden in full bloom. Later, in 1884 and 1885, he painted a fluted copper bowl on the drawing-room table, filled with red and pink geraniums set off against a blue backdrop; then, a bouquet of freshly cut roses from Madame Bérard's garden. In its consummate beauty, this latter still life conveys the intense delight of the artist with great immediacy to the viewer, who in turn enjoys it to the full.

The Rose Garden and the Château de Wargemont, 1879. Canvas, 25⁵/8 × 31⁷/8 in. Paris, Private collection.

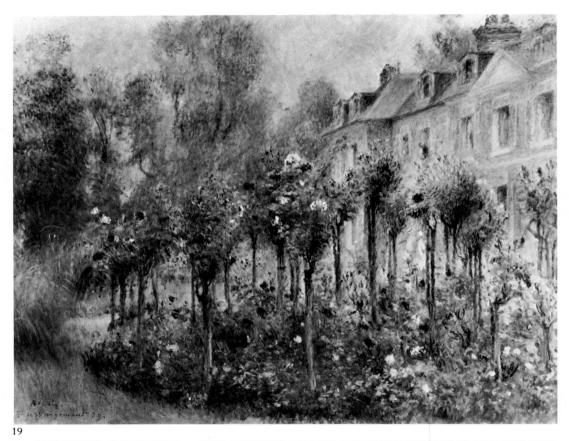

- 20 Geraniums in a Copper Vase, 1884. Canvas, 31⁷/8 × 25¹/4 in. Geneva, Private collection.
- 21 The Roses of Wargemont, 1885. Canvas, 14¹/₄×18¹/₈ in. Paris, Private collection.

Smiling faces at Wargemont

Each of the Bérard children posed for Renoir at one time or another. The sittings were brief and sometimes took place on the spur of the moment, for what Renoir sought above all was naturalness and spontaneity, not prim or strained poses. The portrait of his friends' second daughter Marguerite, known as Margot, was done in just such extempore fashion: meeting the

The Château de Wargemont, photograph.

little girl in tears, he consoled her by proposing to portray her as a merry child and finished the portrait within a few minutes. Two years later, again at Wargemont, he did multiple portraits of all four Bérard children on the same canvas. An appealing tenderness emanates from these young faces which, one senses, belong to children on whom affection has been lavished. One day Renoir also painted the likable face of Léon, the valet who remained in the Bérards' service for forty

23 Marguerite Bérard ("Margot")

in 1879, photograph.

Margot Bérard as a Little Girl, 1879. Canvas, $16^{1/8} \times 13$ in. New York, The Metropolitan Museum of Art.

Williamstown (Mass.), The Sterling and Francine Clark Institute.

26 The Valet of Paul Bérard, 1879. Canvas, $8^{5/8} \times 6^{1/4}$ in. Porto Ronco, Private coll.

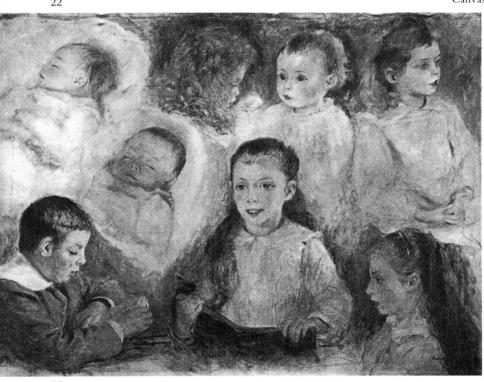

Afternoon at Wargemont

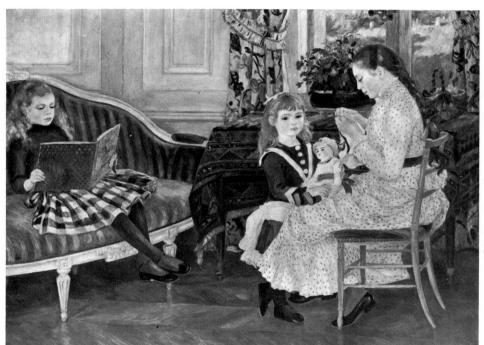

27 The Children's Afternoon at Wargemont, 1884. Canvas, 51¹/₄×67 in. Berlin, Nationalgalerie.

27

It was at Wargemont, in 1884, that Renoir painted some of the most significant works of his "Ingresque" period. In one large-sized canvas he brought together Paul Bérard's three daughters: (left to right) Marguerite, Lucie and Marthe. As noted by a recent commentator on Renoir, "The absence of shadows, the intensity of the colors, and the hieratic poses of the figures give The Children's Afternoon the solemnity of a Renaissance picture and the charm of a naïve painting." The two portraits of Lucie Bérard, particularly the one in a white pinafore, show the same rather severe grace, the same draftsmanly precision, and the same purity of style. The Bérards' third daughter and last child, Lucie was born in 1880. She married David Pieyre de Mandiargues, a mining engineer killed in action in World War I.

Little Girl in a White Dress (Lucie Bérard), 1883. Canvas, 24×19³/4 in. Chicago, Courtesy of The Art Institute of Chicago.

The Paul Bérard collection

Paul Bérard was a discriminating collector whose taste was ahead of his time. He owned nearly thirty important canvases by Renoir, including not only portraits of himself and his family but also some landscapes and figure paintings characteristic of Renoir's Impressionist manner, such as The Daydreamer, Woman with a Black Hat, and the Bather of 1879. Paul Bérard was an

enlightened patron of several of Renoir's friends as well. After his death, the auction of his collection which took place at the Galerie Georges Petit in Paris, on May 8-9, 1905, included six Monets, two Berthe Morisots, three Sisleys, a Lépine, two Lebourgs, and watercolors by Harpignies, Morisot, Vernet, and Pissarro.

- 29 Little Girl with a White Pinafore (Lucie Bérard), 1884. Canvas, $13^{3/4} \times 10^{5/8}$ in. Paris, Private collection.
- 30 Lucie Bérard about 1884, photograph.
- 31 Seated Bather, 1879. Canvas, $19 \times 14^{5/8}$ in.
- 32 Woman with a Black Hat, 1876. Oil on paper, $15 \times 9^{7/8}$ in. Paris, Private coll.
- 33 The Daydreamer, 1879. Canvas, $19^{1/4} \times 23^{5/8}$ in. St. Louis (Mo.), The City Art Museum.

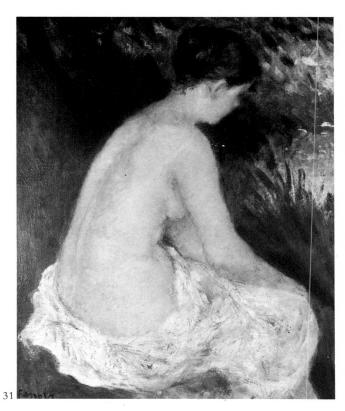

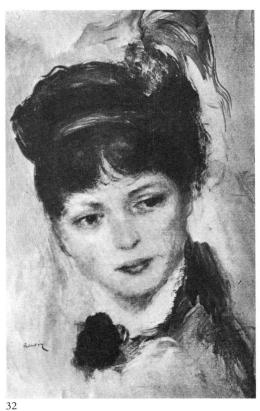

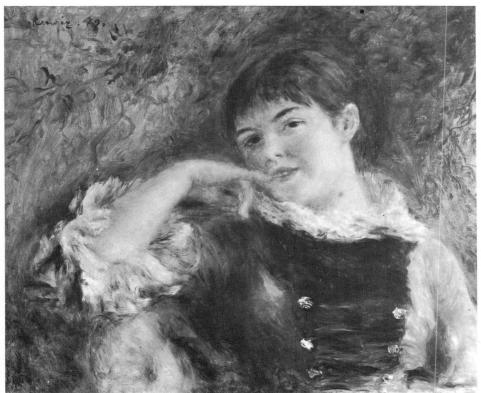

Books about Renoir

Renoir's life and work have been the subject of a great many books and articles. In the first volume of François Daulte's *catalogue raisonné* of his work, the author has listed some 650 items, most of them published in France—as is only natural—but also many issued in England, the United States, Germany, Italy, Spain, and even Japan. Anything like a complete bibliography would necessarily exceed the scope of the present work. Hence, since a judicious sampling was the only alternative, we have limited ourselves to a number of standard basic works, together with some recent studies which throw new light on Renoir.

The first attempt at a catalogue of Renoir's oeuvre was made by Ambroise Vollard. In this two-volume work, published in 1918, the famous dealer reproduced, quite unsystematically, 1,741 paintings, pastels, and drawings which had passed through his hands, plus a number of works from various Paris museums and galleries. Another partial catalogue was published in 1931 by the Galerie Bernheim-Jeune in Paris; this was *L'Atelier de Renoir*, two large volumes compiled by Albert André and Marc Elder. It lists in chronological order the 720 pictures and studies, mostly painted after 1890, which the artist had kept in his house and studio at Les Collettes until his death.

However interesting these initial inventories were, they did not provide anything like a complete listing of Renoir's immense body of work. This gap is now being filled by the *Catalogue raisonné de l'oeuvre peint de Renoir* by François Daulte, published by Editions Durand-Ruel, Lausanne. The first volume, *Figures (1860-1890)*, was issued in 1971; with a foreword by Jean Renoir and a lengthy preface by Charles Durand-Ruel, it includes 646 items all reproduced and described, a critical study of Renoir's art, a detailed biography, a bibliographical dictionary of the artist's models, and an index of owners of his works. This first volume will be followed by four others: two on Renoir's figure paintings of 1891–1919, one on his landscapes, and one on his still lifes.

Renoir's etchings and lithographs were catalogued by Loys Delteil in *Le Peintre-Graveur illustré*, *Camille Pissarro*, *Alfred Sisley*, *Auguste Renoir*, Paris, 1923, vol. XVII. A comprehensive study of his bronzes was made by Paul Haesaerts, *Renoir sculpteur*, Editions Hermès, Paris-Brussels, 1947.

Renoir's own writings were limited to two articles in *L'Impressionniste* (April 14 and 28, 1877); a projected manifesto for a "Société des Irrégularistes," written in May 1884; and a prefatory letter to the French translation by Victor Mottez of Cennino Cennini's treatise on art, *Le Livre de l'art, ou Traîté de la peinture*, Bibliothèque de l'Occident, Paris, 1911. He did, however, write a great many letters. No edition of his collected correspondence has yet appeared, but lengthy excerpts from his letters have been published in the following books and periodicals: "Renoir," in *Bulletin des Expositions Braun*,

Paris, 1932, no. 1; Jules Joets, "Les Impressionnistes et Chocquet," in L'Amour de l'Art, Paris, April 1935; Michel Florisoone, "Renoir et la Famille Charpentier," in L'Amour de l'Art, Paris, February 1938; Lionello Venturi, Les Archives de L'Impressionnisme, Editions Durand-Ruel, Paris-New York, 1939, 2 vols.; Remus Niculescu, "Georges de Bellio, l'Ami des Impressionnistes," in Revue Roumaine d'Histoire de l'Art, 1964, vol. I, no. 2; "Lettres de Renoir à Paul Bérard," in La Revue de Paris, December 1968; Barbara Ehrlich-White, "Renoir Trip to Italy," in The Art Bulletin, 1969, vol. LI.

In Renoir's later years and after his death, several of his friends and pupils published recollections of him in essays and articles which, together with the letters already published or as yet unpublished, provide an essential source of information about his work and way of life. These firsthand accounts are here listed in chronological order: Edmond Renoir, "Le peintre Renoir: Lettre à Émile Bergerat," in La Vie Moderne, Paris, June 19, 1879, no. II; Walter Pach, "Interview with Renoir," in Scribner's Magazine, New York, 1912; Julius Meier-Graefe, Auguste Renoir, Editions H. Floury, Paris, 1912; Ambroise Vollard, La Vie et l'oeuvre de Pierre-Auguste Renoir, Editions Vollard, Paris, 1919 (and Renoir, An Intimate Record, New York, 1925); Albert André, Renoir "Les Cahiers d'Aujourd'hui," Editions Crès, Paris, 1919; Georges Rivière, Renoir et ses amis, Editions H. Floury, Paris, 1921; Théodore Duret, Renoir, Editions Bernheim-Jeune, Paris, 1924; Jeanne Baudot, Renoir, ses amis, ses modèles, Editions Littéraires de France, Paris,

Finally, we cite the following monographs and studies, dealing with his work as a whole or particular aspects of it and containing valuable documentation: Julius Meier-Graefe, Renoir, Editions Klinkhardt & Biermann, Leipzig, 1929; Albert Barnes and Violette de Mazia, The Art of Renoir, Minton, Balch & Co., New York, 1935; Maurice Bérard, Renoir à Wargemont, Editions Larose, Paris, 1939; Denise Rouart, Renoir, Editions Skira, Geneva-London-New York, 1954; François Daulte, Pierre-Auguste Renoir: Aquarelles, pastels et dessins, Editions Phoebus, Basel, 1958; Michel Drucker, Renoir, Editions Pierre Tisné, Paris, 1955; Willi Schuh, Renoir und Wagner, Editions Eugen Rentsch, Zurich, 1959; Douglas Cooper, "Renoir, Lise and the Le Coeur Family: A Study of Renoir's Early Development," in The Burlington Magazine, May, September, October 1959; John Rewald, The History of Impressionism, The Museum of Modern Art, New York, 1961; Jean Renoir, Renoir, Editions Hachette, Paris, 1962 (and Renoir, My Father, Boston, 1962); Henry Perruchot, La Vie de Renoir, Editions Hachette, Paris, 1964; François Daulte, "Renoir, son oeuvre regardé sous l'angle d'un album de famille," in Connaissance des Arts, Paris, November 1964; John Rewald, "Chocquet and Cézanne," in La Gazette des Beaux-Arts, Paris, July-August